pastels
in 10 steps

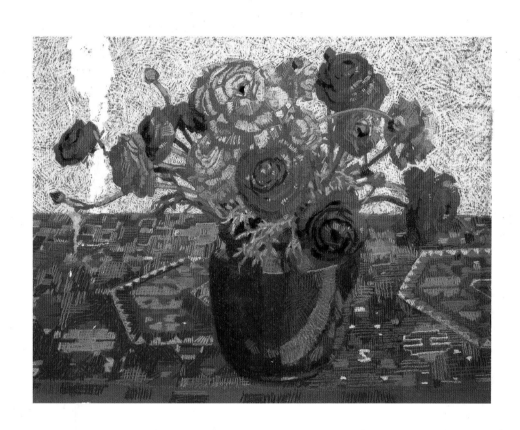

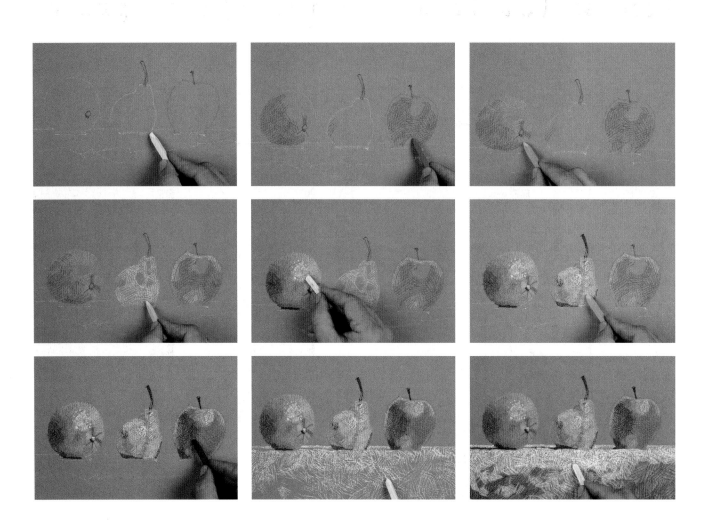

Ian Sidaway

pastels
in 10 steps

Learn all the techniques you need in just one painting

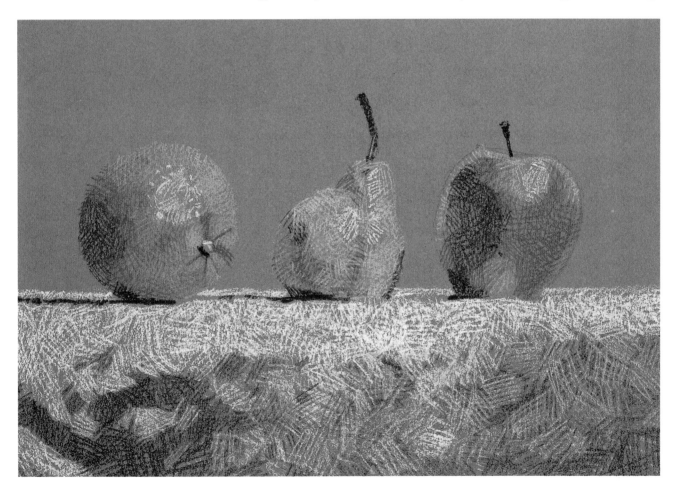

hamlyn

An Hachette Livre UK Company
www.hachettelivre.co.uk

First published in Great Britain in 2008 by Hamlyn,
a division of Octopus Publishing Group Ltd
2–4 Heron Quays, London E14 4JP
www.octopusbooks.co.uk

Distributed in the United States and Canada by
Sterling Publishing Co., Inc., 387 Park Avenue South,
New York, NY 10016-8810

ISBN: 978-0-600-61660-3

A CIP catalogue record for this book is available from the British Library

Printed and bound in China

10 9 8 7 6 5 4 3 2 1

contents

introduction 6

before you begin 8

Step 1 **preparation and foundation 20**

Step 2 **colour 28**

Step 3 **linear techniques 36**

Step 4 **impasto 44**

Step 5 **layering and blending 52**

Step 6 **textural techniques 62**

Step 7 **erasing and sgrafitto 72**

Step 8 **support colour 80**

Step 9 **composition 88**

Step 10 **bringing it all together 94**

taking it a step further 112

index 142

acknowledgements 144

introduction

Pastels are a remarkably simple and pure painting material; pigment is simply mixed together with a resin or gum to hold it together, rolled or compacted into small sticks and allowed to dry. The crumbly nature of the material means that when it is applied to a slightly textured surface the pigment is rubbed away from the stick and transferred to the surface. Unlike other forms of painting, there is no mixing of colours on the palette and no addition of water, oil or synthetic painting medium. You do not need any tools to apply the pigment – in fact, when you are working with pastels it can seem as if colour is flowing from your very fingertips, and there is no waiting around for the paint to dry.

You will notice that I have referred to work in pastels as pastel painting, for it is in essence a way of painting using 'dry' colour. You will also discover that many pastel techniques share the same names used with other painting materials, for example impasto, glazing and scumbling. However, the method of applying pastel is more akin to drawing, which means that techniques from both drawing and painting can be combined.

Pastels are derived from the use of naturally occurring coloured chalks for drawing, something mankind has done since prehistory. However, pastels as we know them today have only been available since the early 16th century, which makes them a relatively modern painting material. Although they are now seen as a traditional medium, they have much to offer the artist working today.

There is no right or wrong way to apply pastels, but there are techniques that make painting with pastels easier. In any medium, much

of the act of creating a painting is concerned with doing things in the
correct order, and this is certainly true in the case of pastels. This book is
intended as an introduction to pastels that will take you through how to
create a pastel painting from start to finish, helping you to avoid any
pitfalls and teaching you a wide range of useful tips and techniques that
are easy to learn. It is arranged as a series of lessons that explain in detail
what materials to use, how to choose a suitable surface, how to lay the
foundations and how to establish tone, colour and texture; you will
discover how to create a pleasing composition (the organization of the
elements in the picture), and how to manipulate pastels to create a wide
range of effects. Three projects then show you how to put all that you
have learnt into practice, which will enable you to go on and create
original images of your own. You will find that pastels are relatively easy,
extremely versatile, immensely satisfying and great fun.

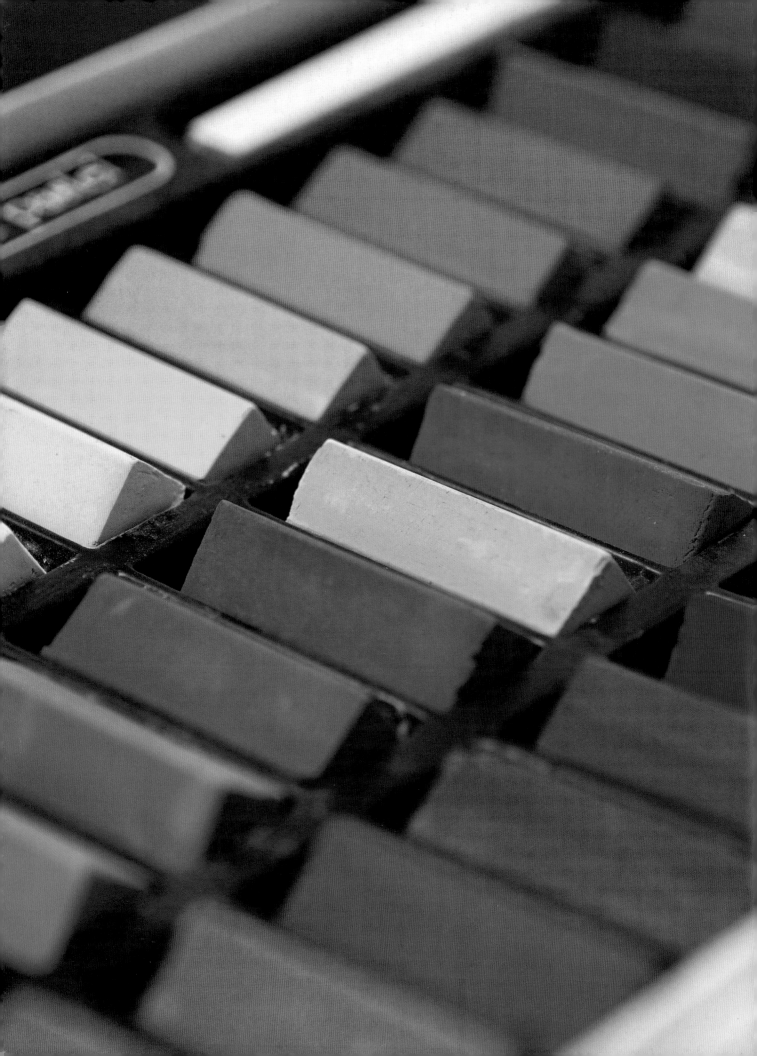

before you begin

choosing the right materials

Compared with oil, acrylic or watercolour painting, pastel painting requires very little equipment; all you will need is a range of pastels and a surface on which to paint. No thinners or oils are called for and although you can manipulate the pigment on the surface with various tools, for the most part you can do it with just your fingers.

Shopping list

Miscellaneous:

Fixative

Paper towel

Torchon (paper stump – these are very cheap, so buy several of different sizes)

Sharp craft knife or scalpel

Painting surfaces:

30 x 36 cm (12 x 14 in) light ochre pastel paper

23 x 30 cm (9 x 12 in) light grey pastel paper

28 x 38 cm (11 x 15 in) light brown pastel paper

24 x 32 cm (9½ x 12½ in) light brown pastel board

21 x 29 cm (8½ x 11½ in) dark brown pastel paper

28 x 38 cm (11 x 15 in) mid green pastel paper

25 x 33 cm (10 x 13 in) blue pastel paper

53 x 74 cm (21 x 29 in) light brown pastel paper

53 x 74 cm (21 x 29 in) dark brown pastel paper

53 x 74 cm (21 x 29 in) deep blue pastel paper

Pastels:

Cadmium yellow deep (Hard/Soft)

Cadmium yellow (Hard/Soft)

Lemon yellow (Hard/Soft)

Deep orange (Hard/Soft)

Orange (Hard/Soft)

Light orange (Soft)

Cadmium red (Hard/Soft)

Crimson (Hard/Soft)

Dark red (Hard/Soft)

Burnt sienna dark (Soft)

Burnt sienna (Hard/Soft)

Burnt sienna light (Soft)

Light warm grey (Hard/Soft)

Warm grey (Hard/Soft)

Dark warm grey (Hard/Soft)

Dark cool grey (Hard)

Light cool grey (Hard/Soft)

Black (Hard/Soft)

Cerulean blue (Hard/Soft)

Cerulean blue deep (Hard)

Cobalt blue (Hard)

Ultramarine (Hard)

Payne's grey (Hard/Soft)

White (Hard/Soft)

Raw umber light (Hard/Soft)

Raw umber (Hard/Soft)

Vandyke brown (Hard/Soft)

Burnt umber (Hard/Soft)

Raw sienna (Hard/Soft)

Raw sienna deep (Hard)

Yellow ochre (Hard/Soft)

Ivory (Hard/Soft)

Light violet (Soft)

Violet (Hard/Soft)

Viridian (Hard/Soft)

Oxide of chromium (Hard/Soft)

Grey green (Hard/Soft)

Lime green (Hard/Soft)

Dark olive green (Hard)

Olive green (Hard)

Light green (Hard/Soft)

Mid green (Hard/Soft)

Dark green (Hard/Soft)

Pink (Hard)

The materials needed are available at most art stores. Buying a range of pastels to work with is slightly different to buying a set of oil, acrylic or watercolour paints, where it is possible to obtain a basic palette of colours that will enable you to mix most of the hues, tints and tones you will ever need. Because of the way in which pastels are made and applied, mixing is intended to be kept to a minimum. Purchase both hard and soft pastels for those colours where both types are given in the shopping list opposite.

PASTELS

Pastels are made by mixing a pigment or pigments together with an inert filler and a binder. The pigment is the substance that provides the colour, and traditionally its source is either organic (derived from animal or plant sources) or inorganic (derived from salts or metallic oxides). However, these days many pigments are manufactured synthetically. The filler (usually chalk) is added to bulk out the pigment and allow it to be made into a paste when it is mixed with the binder, which normally consists of a type of gum.

The wet paste is compressed into a stick, cut to length and allowed to dry.

Types of pastel

Pastels can either be hard or soft. However, as the characteristics of the individual pigments differ, some soft pastels are harder than others. The degree of softness can also vary according to the brand.

Soft pastels are traditionally round and wrapped in a paper sleeve which helps to hold the pastel together. Hard pastels, sometimes referred to as chalks, have no paper sleeve and are usually square in profile. The manufacturing process is very similar to that for soft pastels, but more binder is added to make the stick stronger. Hard pastels can be carefully sharpened to a point, making them ideal for rendering detail.

Pastel pencils resemble traditional coloured pencils, but the pigment core is made from a mixture very similar to that of hard pastels. They are more of a drawing tool and are useful for adding detail to images created with traditional hard or soft pastel. All of the different types and brands of pastel can be intermixed.

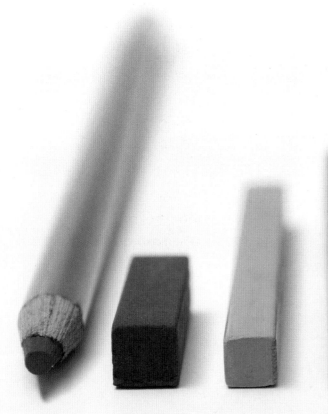
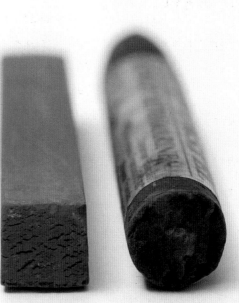

CHOOSING A RANGE OF PASTELS

Pastels are applied directly to the surface in the same way that you would use a coloured pencil. Because of their softness, once they are on the surface you can mix and blend them in a variety of ways. However, in order to avoid the pastel painting from looking overworked it is best to keep this to a minimum. It is for this reason that pastel manufacturers create a wide range of tints and tones of each colour, and given that no two brands of pastels will provide exactly the same colours, there are an awful lot of colours, tints and tones available. It is impractical to buy every one of these colours, so where to begin?

All manufacturers supply sets of pastels that provide a range of colours to get you started. Many also offer sets that include a range of colours suitable for painting specific subjects, such as portraits or landscapes. These are tempting for the beginner, but it is far better to choose your own set of colours to suit your intended subjects and buy a separate box in which you can store and protect them.

For this book I have done exactly that and all of the projects have been executed using these pastels. Because manufacturers sometimes use different names for the same colours, I have chosen a set of pastels and given them my own generic names such as burnt sienna deep, burnt sienna or burnt sienna light. In some cases these will be the same as the actual manufacturers' names, while in others they will be names that I have picked because I think they match the characteristics of that particular colour. If this sounds a little complicated, simply take this book with you to the art store and match your selection of pastels as closely as you can to the colours in the colour palette chart on pages 18–19.

I have chosen these colours for several reasons. They give a range of warm and cool variants of each of the main colour groups (see pages 30–31) and also provide a range of tones, essential for indicating form. They are all easily available from several different manufacturers, and they will give you a very good basic set of pastels that you can build on as and when you feel it necessary.

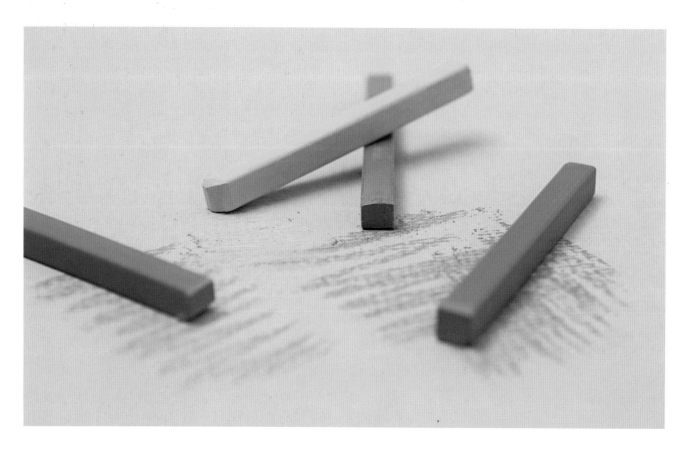

LOOKING AFTER YOUR PASTELS

Pastels are relatively delicate and will break if they are dropped or used carelessly. Soft pastels are for the most part sold with a protective wrapper, on which is printed the manufacturer's name, the colour name and often the code of the pigments used. This wrapper is there to protect the pastel in transit and to add a degree of strength and stability. It can be torn away as the pastel is used but it is best not to remove it completely. To some extent the paper wrapper will also prevent pigment from getting onto your fingers.

Rather than keep pastels loose it is better to store them in a box. Any flat box that will prevent the pastels from clattering around and becoming broken will do, but you can find several types of box made specifically for the task at art stores. These boxes are constructed to the correct depth so that the pastels will not move around unduly during transport. Some have foam inserts that pad the pastels and prevent them from rolling around, while larger ones have drawers which are divided into sections so that the pastels can be arranged according to colour and type.

KEEPING PASTELS CLEAN

Pastels (particularly the soft type) can become dirty as pigment is transferred from pastel to pastel, either by close proximity to one another or by pastel-covered fingers. Fortunately, the solution is very simple: take a clean glass jar with a screw lid and three-quarters fill the jar with dry uncooked rice of any type. Push the dirty pastels into the rice, put the lid on and shake the jar gently. The abrasive action of the rice removes the dirty surface of the pastel to reveal the true colour beneath. Replace the rice once it is dirty.

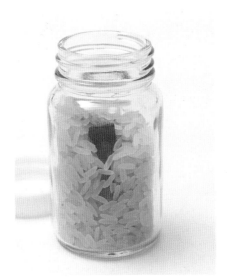

Cleaning pastels: The larger the jar, the more pastels can be cleaned at any one time.

FIXATIVE

The surface of a pastel painting is delicate; if it is rubbed or shaken the pigment can easily be dislodged or smudged and the painting potentially ruined. In order to prevent this from happening, pastel paintings are usually 'fixed'. This means giving the painting a coat of fixative which holds the pigment dust in place.

Fixative consists of a colourless resin which is carried in a clear spirit solvent. Once it is applied to the painting the solvent evaporates quickly, leaving the resin behind to fix the pigment dust to the surface. The fixative is applied by atomizing it into tiny droplets which are sprayed onto the surface in one of three ways. The easiest of these is to use an aerosol can which delivers the fixative very evenly to the surface. The second way is by a pump-action spray, which is attached to the top of the fixative bottle and operated by your finger. The third way is via a mouth-operated atomizer. This consists of two hollow tubes joined at one end by a hinge, which opens out so that the tubes sit at 90 degrees to one another. Place one end of one tube in the bottle of fixative and the other in your mouth. Blowing down the tube causes the fixative to rise up the tube and atomize into a fine spray that is blown onto the surface.

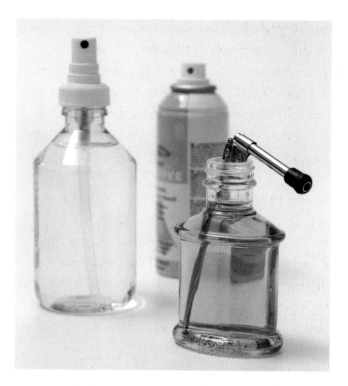

Fixatives: There are various ways of applying fixative.

Applying fixative can dull the colours slightly, especially lighter tints, and for this reason many pastel artists choose not to use it. However, it does have the advantage that you can extend the range of tones by fixing then applying another layer of similar colours. Many artists fix during the painting process and finally apply the lighter accents and passages which are left unfixed to preserve their brightness.

PASTEL PAINTING SUPPORTS

Pastels can be applied to a variety of supports (the materials, or surfaces, upon which you paint), ranging from paper to board; in theory, they can be used on any surface that has sufficient tooth or texture to hold the pigment dust. This includes relatively smooth white drawing (cartridge) paper. In practice, however, it is better to use a surface that is made specifically for pastel work in order to build up sufficient depth of colour. The surfaces of pastel supports all have slightly different characteristics, with some much rougher or coarser in texture than others, and the choice of which to use is entirely a personal one.

As a general rule, those surfaces that are very rough are the most difficult to work with. Either side of textured papers intended for pastel can be used, with one side usually being slightly smoother than the other. Which side to use is a personal preference.

Supports are also available with a 'sanded' surface, coated with sand, silica, pumice, marble dust or a finely ground vegetable paste. Only the coated side of these papers is used. This type of surface is also applied to rigid card to make pastel boards, where again only the coated side of the support is used. At the oppposite end of the scale, you can also buy a softer surface support that resembles a smooth material like velour.

If you wish to create your own surface you can buy liquid grounds in a range of colours that you can paint on to either paper or board. These invariably consist of a liquid gesso mixed together with a pumice or marble dust which dries to leave a hard, finely textured surface. Alternatively, it is an easy task to prepare your own using an acrylic gesso into which you mix marble dust and, if you wish, acrylic paint of any colour.

Coloured supports

In pastel painting the support colour is very important as it affects the quality of the colours that are applied. Because pastels are used on a textured surface, this surface will inevitably show through in places and will have a profound influence on the finished work.

There are several considerations to take into account when you are choosing the colour and tone of the support for a particular painting. You may want to set an overall tonal value for the work, be it light, medium or dark. Alternatively, you may want the colour and tone to give an overall sense of warmth or coolness, or to provide the dominant or background colour of the subject. A contrasting colour will make the applied colours 'sing', or appear much brighter than they actually are. Subtle neutral colours – ochres, browns, greens, blues and greys – are easier to work with, but as long as you take care, you will be able to achieve stunning results by using very strong bright colours that inevitably make the applied pastel colours really sing out.

You can use white papers and supports if you wish, but the pastel colours will lack the punch that they have when applied to a support that is even relatively light in colour or tone. If you cannot conveniently lay hands on a support in the colour you want, you can tint any white watercolour paper using either watercolour, gouache or acrylic paint.

MANIPULATING PASTEL ON THE SUPPORT

While you apply colour to the support with the pastel itself, once it is there you can manipulate it in a number of ways. The most convenient is to use your hand and fingers. Indeed, it will become second nature to blend or soften colours using your fingers, the only drawback being that it will necessitate numerous visits to the wash basin! Make sure that your hand and fingers are dry and grease-free and avoid eating food or putting your fingers in your mouth if they are covered in pigment.

The traditional tool for manipulating dry, crumbly drawing materials is the torchon, or tortillion, which is simply a stump of rolled or pulped paper with a point at one end, or sometimes both. These paper stumps are inexpensive and available in various sizes. The larger stumps can be used for broad work and the smaller ones for fine detail. They can become dirty with use but it is an easy task to clean and sharpen the point by rubbing it on a fine grade glass paper.

You can also manipulate the pigment with sponges, cotton-wool buds, paper towels or brushes. While you can use any brush intended for watercolour, oil or acrylic paint, there are also a range of brushes made specifically for pastel work.

Erasers: Paper stumps are pointed in order to facilitate detailed eraser marks.

The ability to remove pigment from the support is important, not so much to make corrections but as a means of creating textural effects and adding highlights. You can do this with brushes, torchons and other mark-making tools and also erasers. The pigment can clog and make them dirty very quickly, but handled with care they can be very useful. Putty erasers get dirty far quicker than rubber or vinyl erasers, but a simple solution to this is to cut the eraser into small pieces then discard each piece as and when it becomes too dirty to use.

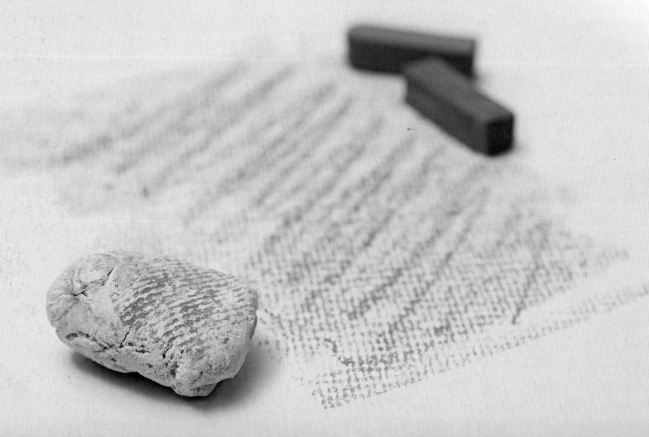

Soft pastels need to be sharpened with care as they break easily.

Hard and soft pastels can be given a point on glass paper.

A sharp craft knife will give a good point on hard pastels.

SHARPENING PASTELS

Soft pastels are difficult to sharpen as they break very easily. It is far better to use the pastel in such a way that the action of applying it on the support wears it down, creating a sharp edge or a point. However, you can maintain a sharp edge on a soft pastel by cutting it at right angles across its diameter. Alternatively, sharpen it by rubbing it on a piece of fine grit glass paper. Hard pastels, on the other hand, can be sharpened successfully by carefully using a sharp craft knife or a scalpel.

ADDITIONAL EQUIPMENT

You will need a drawing board on which to secure your support. These are made of wood and available in a range of sizes. Choose one that is large enough to accommodate the largest size of paper that you are likely to use. To hold the support on the drawing board, it is best to use clips rather than tape or drawing pins as they do not damage the corners of the support. When you are choosing clips, make sure that they will open wide enough to accommodate the thickness of the drawing board and support.

An easel is perhaps a luxury that you can initially do without, though you will find that a good sturdy easel makes positioning the support easy and practical. The easel you choose depends on practicalities such as cost, the angle at which you like the support, whether you prefer standing or sitting down to paint and if you are going to be working on location. In all instances, choose the best that you can afford to ensure that it will last a long time and is stable and easily adjustable. Some easels on being set up can fight back in much the same way as deckchairs!

You may find a mahlstick useful – a traditional piece of equipment that consists of a wooden or metal stick with a soft ball at one end. The soft tip can be placed on the edge of the painting and the stick held in the non-drawing hand. The stick then acts as a support for your drawing hand and keeps it away from the work. Finally, use a roll of paper towel for wiping your hand, dusting off excess pigment and making corrections.

THE COLOUR PALETTE

The pastels used for the projects in the book were from various manufacturers and varied in degrees of hardness. For the exact type of pastel, refer to the materials list in the introduction to each project. The main projects used a combination of hard and soft pastels. My suggestion is that you equip yourself with both hard and soft variants of each colour used. As I have used generic titles for my pastel colours, to match up the palette take the book to your art store and choose a range of pastels that match the colour swatches here. Do not be over-concerned if you cannot make an exact match – as long as the colours are similar you will be able to complete the projects.

Colour list

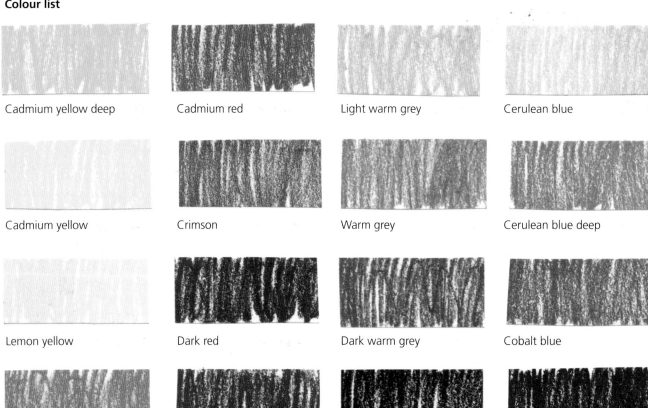

Cadmium yellow deep	Cadmium red	Light warm grey	Cerulean blue
Cadmium yellow	Crimson	Warm grey	Cerulean blue deep
Lemon yellow	Dark red	Dark warm grey	Cobalt blue
Deep orange	Burnt sienna dark	Dark cool grey	Ultramarine

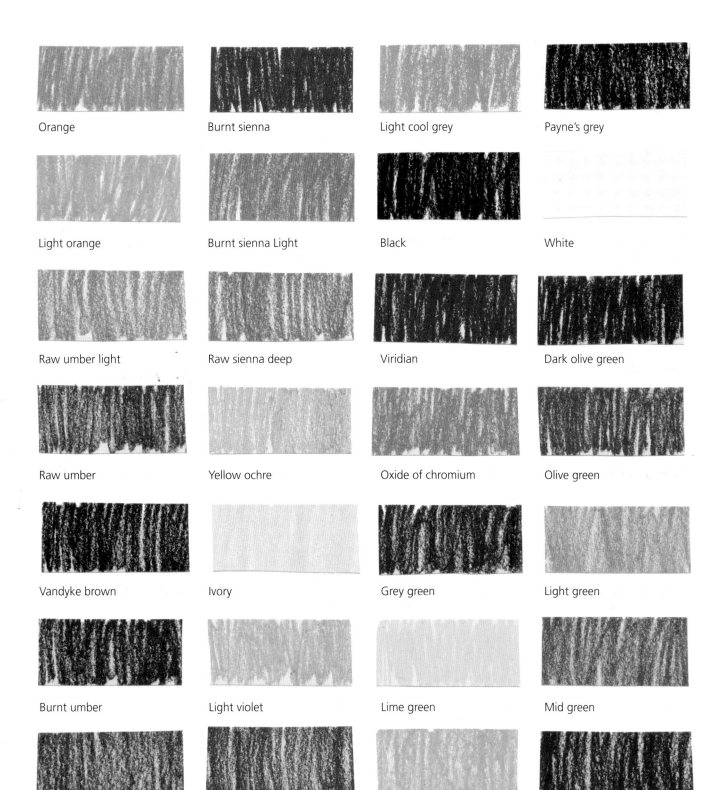

Orange

Burnt sienna

Light cool grey

Payne's grey

Light orange

Burnt sienna Light

Black

White

Raw umber light

Raw sienna deep

Viridian

Dark olive green

Raw umber

Yellow ochre

Oxide of chromium

Olive green

Vandyke brown

Ivory

Grey green

Light green

Burnt umber

Light violet

Lime green

Mid green

Raw sienna

Violet

Pink

Dark green

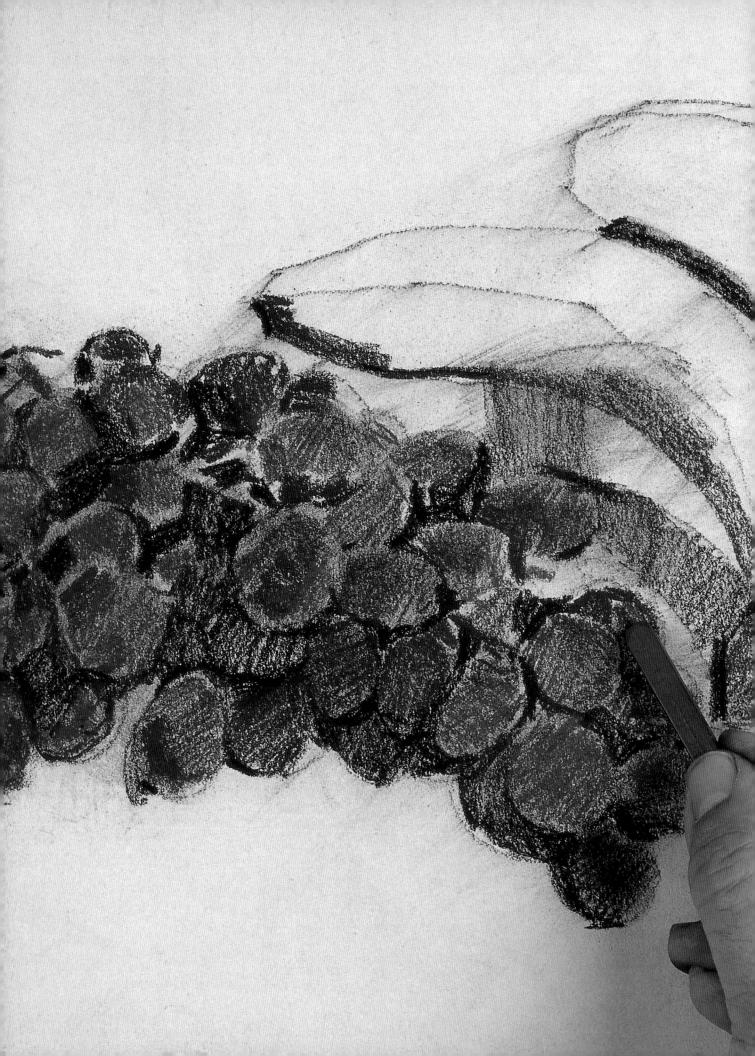

Step 1

preparation
and foundation

Step 1 **preparation and foundation**

focus: grapes and bananas

Materials

30 x 36 cm (12 x 14 in) light ochre
 pastel paper

Fixative

Paper towel

Hard pastels:

- *Black*
- *Violet*
- *Light violet*
- *Burnt umber*
- *Raw sienna*
- *Mid green*
- *Cadmium yellow*
- *Cadmium yellow deep*
- *Payne's grey*
- *Ivory*
- *White*

There is an old adage that goes 'Plan to fail by failing to plan.' This is a truism that applies to all types of drawing and painting but is especially apt when working in pastel. The problems arise from choosing the wrong support type (see pages 14–15), something we will look at in more depth on pages 80–87, and from applying too thick an application of pastel in the early stages of the work.

Pastel dust needs a textured support on which to adhere. If the support is too smooth, you can make a mark but not enough pigment will be left behind, making it an almost impossible task to build up sufficient depth of colour. If the support is too coarse the exact opposite happens – too much pigment can attach itself to the support, making it very difficult to apply subsequent layers. The support texture also makes for a very open-textured image that is not always pleasing. Papers intended for pastel

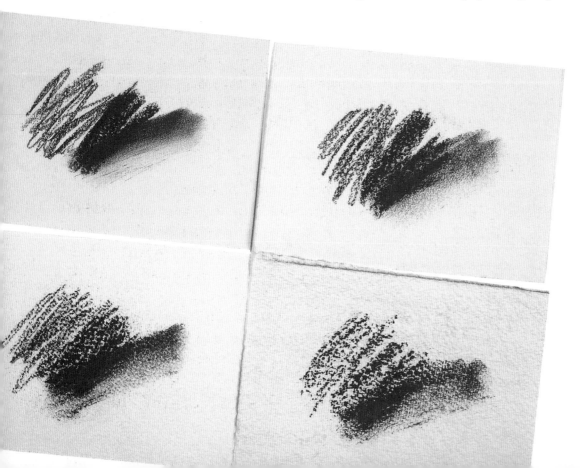

Support surfaces:
These four support surfaces have different textures but you can see how similar pastel marks look on each.

Hard pastels: Harder pastels and chalks are often better used in the initial stages of a painting as they deposit less pigment dust and do not clog up the texture, or tooth, of the support.

Removing dust: You can easily remove excess pastel dust by flicking over the area with a soft rag or a bristle brush. This must be done prior to applying fixative.

paintings have been made with this in mind and have a surface tooth or texture that marries perfectly with the delicate pigment dust.

A pastel painting is invariably constructed using a series of layers. As with painting in other mediums, the initial layer is either a drawing which will help keep further applications on track or a loose underpainting which puts in the elements of the picture and can concentrate on tone, colour or general shape and positioning. Often the drawing and the underpainting are made in such a way that they are indistinguishable from one another.

When you are painting in pastels it pays to use a loose approach at first, gradually tightening and defining specific areas as you work. It is not easy to make fine, precise or intricate detail with pastels but this method does make it possible.

UNDERDRAWING AND UNDERPAINTING

For the underdrawing, you can use charcoal instead of pastel. The dark charcoal dust may mix with the lighter pastel colours, but this can be alleviated by fixing the charcoal drawing before adding pastel. (Charcoal can also be used instead of black pastel at any point as it mixes with pastels very well.) Do not use graphite pencils for the underdrawing as sometimes the pressure you will need to apply leaves a slight indentation on the support surface which remains visible through the pastel work. Once you have finished the drawing, flick over the support with a soft rag or a large soft brush to remove any superfluous pastel and to prevent an early build up.

The same technique can be used on the underpainting, which is made with broad applications of pastel. The colours and tones are usually simplified to suggest local colour and the main areas of light, mid and dark tone. Many artists use the harder pastels for underpainting as, by their very nature, they deposit less pigment dust when used. This helps you to establish a good foundation for subsequent work unencumbered by a thick layer of pigment dust.

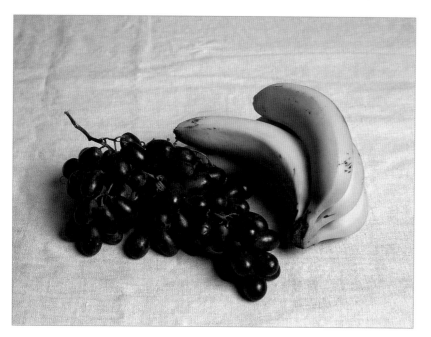

PAINTING THE GRAPES AND BANANAS

The grapes and bananas chosen for this exercise each consist of several small shapes that join together to make the whole. The exercise shows you how to loosely plan out the image so that you build a strong, informative foundation that will act as a guide for your subsequent applications of pastel. You will also discover just how to avoid a premature build-up of pigment dust.

1 Begin by using a hard black pastel to sketch out the shape and position of the bunch of grapes, together with its cast shadow. Work lightly and loosely. You may find it easier to position your lines more correctly if you sharpen the pastel to a point before you begin.

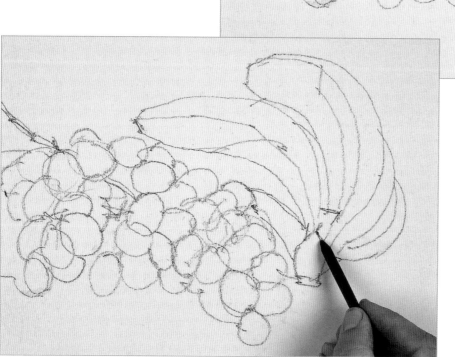

2 Now draw the bunch of bananas, positioning them carefully adjoining and slightly behind the grapes. If you make a mistake, don't panic – simply redraw. Remember, the subsequent pastel work will cover up any mistakes and the drawing is only meant to act as a guide.

3 Even though you have worked lightly you can 'knock back' the drawing further and remove excess black pastel dust by dusting over it with a soft rag, paper towel or bristle brush. There is no need to be concerned if the drawing appears to smudge, but you can give it a coat of fixative if you wish.

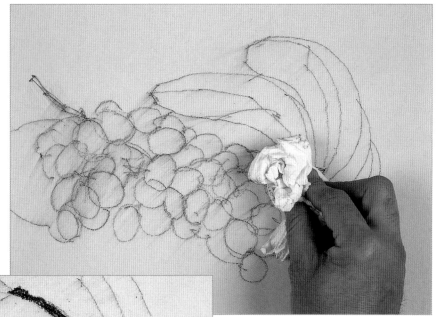

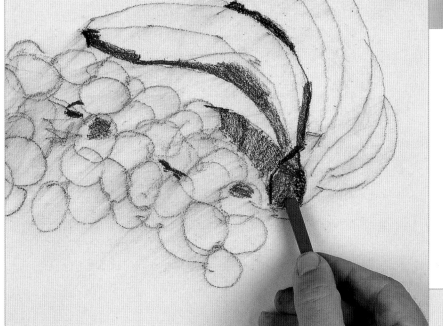

4 With black and burnt umber pastels, scribble simple strokes to block in the darker areas on the grape stalks and the bananas. Do not be concerned if a few patches of the support show through in places.

5 With slightly firmer strokes, use the black pastel to block in the darkest areas on and around each grape and the shadow cast by the bananas. Dust off the excess pigment.

6 Now, using combinations of burnt umber and violet, establish the basic colour of the grapes. As you work, vary the direction of your strokes, occasionally allowing them to follow and suggest the contours of individual grapes. At this stage, do not attempt to represent any highlighted areas.

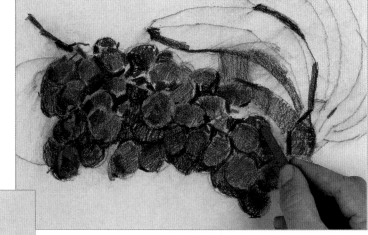

7 Next take the mid green and establish the areas of green on each banana. If this seems too strong do not worry – once the yellows are applied the green will be subdued to some extent. Pick out the stalk of the grapes with the same green. Apply simple strokes of Payne's grey along the edges of each banana in shadow, then use raw sienna to establish a base for the darker yellow areas on each banana where they face away from the light source.

8 Work cadmium yellow deep into the areas of banana where you have already applied raw sienna, which will darken the yellow slightly. Then apply a stronger, brighter cadmium yellow to the sides of the bananas that are in the light. This will mix with the green to give a good representation of the unripe skin.

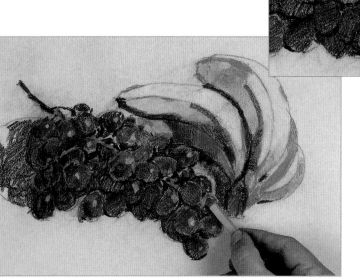

9 Use Payne's grey to paint the shadow cast by the grapes onto the tablecloth then, with simple touches of a light violet pastel, pick out the highlighted areas on some of the grapes.

10 Block in the background with ivory, working carefully around the shape of the grapes and bananas and redefining their outline as you go if you consider it necessary. Build up the colour using a network of multi-directional strokes.

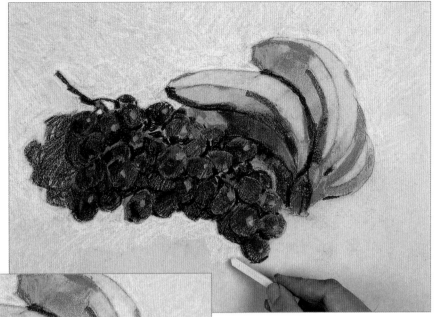

11 Finally, use white to add a highlighted area along the edge of the uppermost banana, then add simple dabs of white to pick out the brighter highlighted areas on the grapes.

12 The finished painting, although complete, is really just an underpainting and could be worked on further if you wish, because the build-up of pigment has been kept to a minimum. Leaving the support to show in places allows for further applications of thicker pastel to adhere easily.

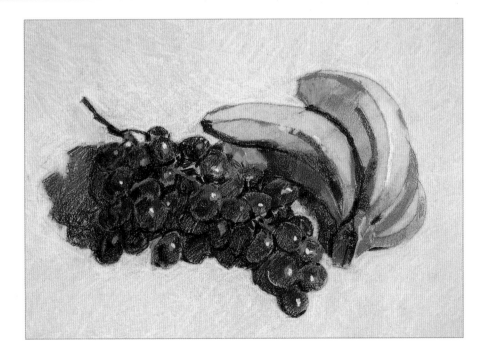

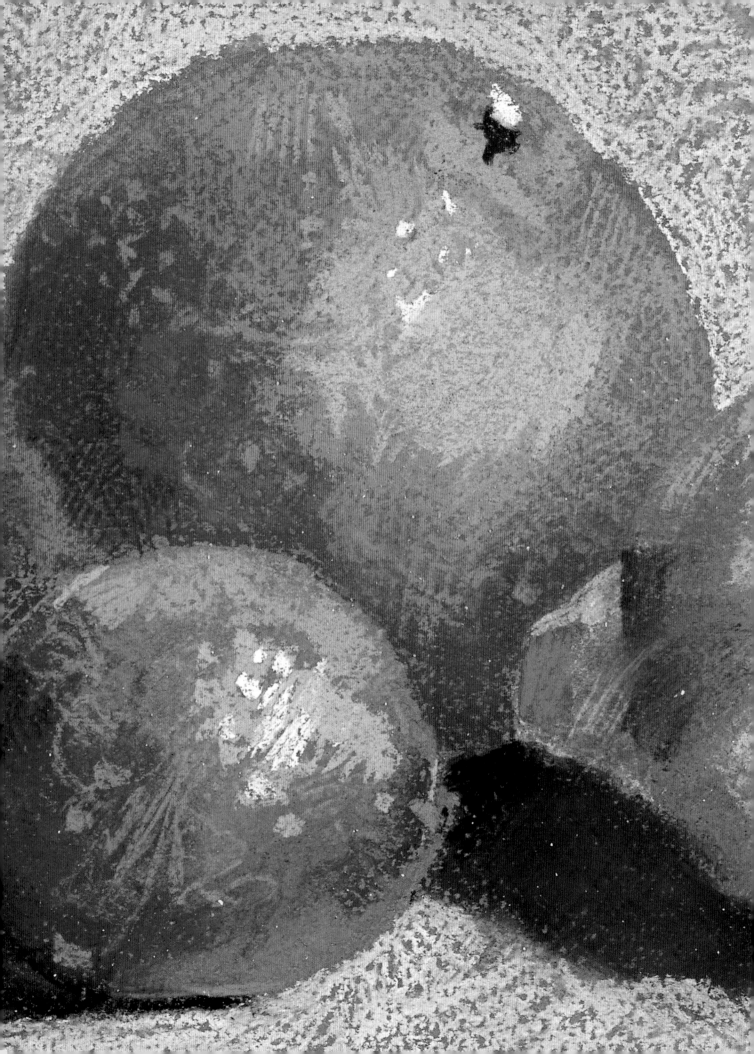

Step 2
colour

focus: orange, lime and lemon

Materials

23 x 30 cm (9 x 12 in) light grey
pastel paper

Soft pastels:

- *Cadmium red*
- *Dark red*
- *Deep orange*
- *Orange*
- *Light orange*
- *Lemon yellow*
- *Cadmium yellow*
- *Viridian green*
- *Mid green*
- *Light green*
- *Payne's grey*
- *Ivory black*
- *Raw umber*
- *Raw umber light*
- *Ivory*
- *White*

You may already be familiar with other painting materials, but when you are working in pastel the approach to colour and colour mixing is slightly different. Pastel is a 'dry' colour and is applied directly to the support with no prior mixing on a palette. While a degree of mixing through blending and layering does take place, it is more usual and often a better policy to keep the colours pure by using a pastel with a colour that approximates the one you want. A little knowledge of basic colour theory and terminology is a useful thing to have and will help you to understand what colour is and does.

Colour wheel

The colour wheel is a standard diagram that shows the progression and order of the colours as they merge from one to another. The wheel corresponds to the progression of the colours in the spectrum which make up white light. It is a useful device for making sense of colour relationships, colour theory and terminology.

Primary colours

The primary colours are red, yellow and blue – colours that cannot be made by mixing other colours together. There are several different versions of each primary colour.

The colour wheel: The wheel shows how the primary colours are mixed with one another to create a range of secondary and tertiary colours.

Tints and tones: Pastels are manufactured so that a range of tints and tones of each hue or colour are available. This cuts down on mixing. Here a light, medium and dark version of ultramarine are shown.

Creating neutrals: Mixing complementary colours together results in a range of neutral browns and greys – but take care you do not end up with dull, dirty colours that all look the same.

Secondary colours

Mixing any two primary colours together results in a secondary colour. For example, red and yellow make orange, yellow and blue make green and blue and red make violet. The exact hue or type of orange, green or violet will depend on which versions of each primary colour were used in the mix.

Tertiary colours

Tertiary colours are created when a primary colour is mixed in more or less equal parts with the secondary next to it on the colour wheel. These colours are red-orange, orange-yellow, yellow-green, green-blue, blue-violet and violet-red.

Complementary colours

Complementary colours fall opposite one another on the colour wheel. They have a very special relationship, in that when they are placed next to one another they make each other appear brighter than they really are. Conversely, when they are mixed together they subdue or neutralize one another. This results in a series of very important colours known as neutrals which include greys and browns.

Colour temperature

Colours are considered to be 'warm' or 'cool'. Red, orange and yellow are warm colours, while green, blue and violet are cool. However, this is complicated somewhat by each colour having both warm and cool variants. For instance, cadmium red is a warm red because it leans towards being yellow; alizarin crimson, on the other hand, is a cool red because it leans towards blue.

Hue

The term 'hue' is simply another name for colour. Ultramarine, cobalt blue and cerulean are all blue hues. Crimson and cadmium red are red hues.

Value

This term is used in relation to tone and describes the relative lightness or darkness of a particular colour.

Saturation

The term saturation describes the relative intensity of a colour. Colours that are similar in hue will have different intensities of colour. Ultramarine is a more intense (more saturated) blue than cerulean, for example.

Harmony

Certain colour combinations are more harmonious than others. Colour harmony can be created in several different ways: monochromatic harmony is achieved by using tones of the same colour; analogous harmony by using groups of colours that are close or next to one another on the colour wheel; and complementary harmony is created by using colours that fall opposite one another on the colour wheel.

PAINTING THE ORANGE, LIME AND LEMON

These three objects are relatively simple in colour and when viewed individually show little colour variation over their surface. However, when they are placed together under a relatively strong light you can see how the colour of each affects the colour of its neighbour. It is the ability to depict this reflected colour that makes an image convincing.

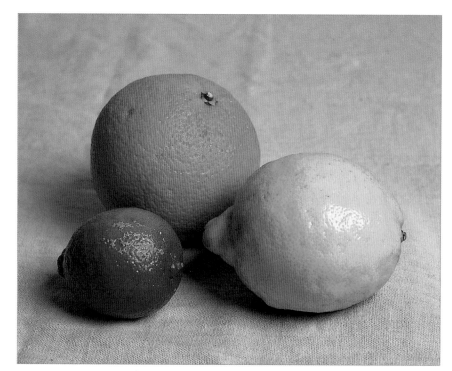

1 Begin by positioning the three objects relative to one another. Using simple shapes, draw the orange using an orange pastel, the lemon with a cadmium yellow pastel and the lime with a mid green pastel. Draw the position of each shadow with black.

2 Using closely aligned strokes and in some places adding a second layer of strokes crossing them (known respectively as hatching and cross-hatching), build up the basic colour of the orange. Use cadmium red for the dark tones in the area away from the light and deep orange for the mid tones.

3 Block in the lighter tones using orange. Work this slightly into the darker areas to soften the transition from dark to light. Put in a few dots of colour to indicate the pitted nature of the orange skin, then work light orange over the orange to suggest the highlight.

4 Use mid green for the mid tones on the lime, followed by an application of viridian green. Work this into the mid green area to soften the transition from one to the other.

5 Cross-hatch light green over these colours to show the highlighted area. A few hatched lines of orange along the top of the lime will suggest the reflected colour from the orange.

6 Moving on to the lemon, use raw umber for the areas in shadow and block in the rest of the lemon with a bright cadmium yellow, working it into the raw umber to produce lighter mid tones. Put in a touch of light orange along the top left of the lemon to indicate the reflected colour from the orange.

7 Work lemon yellow over the top of both the cadmium yellow and the raw umber to define the highlighted areas. Add touches of orange and cadmium yellow to show up the nuances in the lemon's colour.

8 A little green and a dab of yellow and ivory black are all that is needed to suggest the place where the orange was attached to its stalk. Next, draw in the shadows cast by the three objects to anchor them to the surface on which they rest, using Payne's grey for the bulk of the shadow and working black into the area of deep shadow closest to each object.

9 Block in the colour of the tablecloth, using a light raw umber pastel. Work over the area using scribbled cross-hatched strokes – try varying the direction of the strokes as this is far more aesthetically pleasing than allowing all of the strokes to run in the same direction.

10 Now rework the darker parts of each fruit, using the relevant colours as before but with the addition of a little dark red on both the orange and the lime and a little raw umber on the lemon. Add a little red also into the Payne's grey in the shadows. Finally, block in the highlights with a few deft strokes of white pastel.

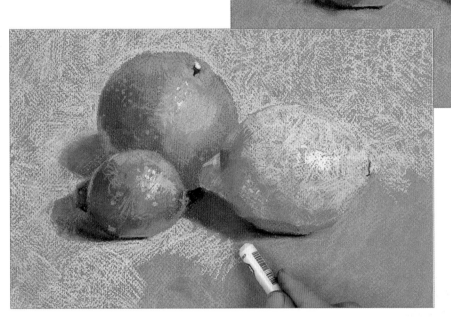

11 Using an ivory pastel, lift the tone of the whole painting dramatically by reworking the table cloth. As before, use multi-directional strokes of the pastel, working carefully up to and around the fruit and the shadows cast by the light source.

12 With the exercise complete, you can see how just two or three tones or tints of a colour are all that you need to create form and depth of colour and how limiting the mixing of colours to a minimum keeps the image bright and clean.

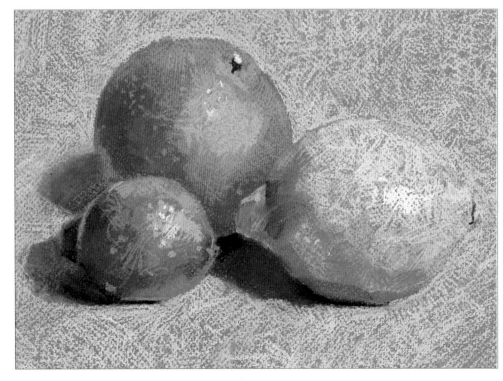

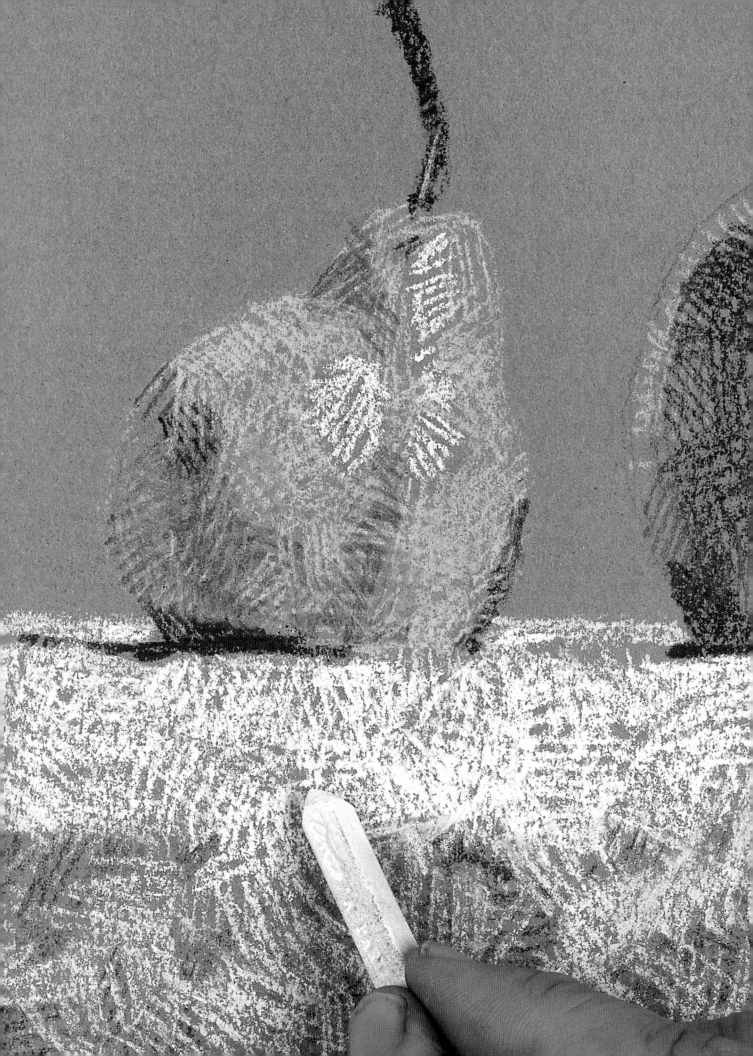

Step 3
linear techniques

focus: orange, pear and apple

Materials

28 x 38 cm (11 x 15 in) light brown pastel paper

Hard pastels:

- *Cadmium red*
- *Orange*
- *Burnt umber*
- *Payne's grey*
- *Ivory*
- *White*
- *Light green*
- *Mid green*
- *Dark green*

Although they are essentially tools for making blocks or broad areas of colour, pastels can also be used to create work that consists of a series of lines. Techniques such as hatching and cross-hatching, done with the intention of building up what appears to be a solid area of colour or tone, are in fact techniques that use line, familiar to anyone who has drawn. It is the ability of pastels to switch from making bold blocks of colour to more intricate line work that makes the medium so versatile. Building areas of colour and tone in this linear way is very controllable. Although entire paintings are made using line work, it is more often than not used in combination with broadly applied areas of colour in order to modify form, add detail or create textural effects.

Soft pastels, hard pastels and pastel pencils can all be used to produce paintings using linear techniques. Needless to say, to make a line that is reasonably fine the drawing implement must have a point or a sharp edge. When you are using pastel pencils this is no problem as they are sharpened in the same way as a graphite or coloured pencil. Hard pastels are also easy to sharpen by carefully using a sharp knife. However, problems arise if you try to sharpen soft pastels to a point as they simply crumble. The trick is to use the 'sharp' edge that runs around the circumference of both ends of the pastel. It is relatively easy to keep this edge by cutting straight across the pastel end using a sharp craft knife (see page 17). In order to keep the edge 'sharp', turn the pastel between your fingers as you work.

LINEAR TECHNIQUES

When you are using hatched, cross-hatched or scribbled lines, the colour intensity and tonal depth are built up by a combination of the line

density (the spacing of the lines) and the pressure applied. An important point to remember is that the lines do not have to be straight. Indeed, drawing lines that curve to follow the form of the subject helps to suggest its shape and form in a very efficient and concise way.

With linear techniques colours tend to mix optically – that is, rather than physically blending, the colours remain separate and visible but are read as a mixed colour by the eye because of their proximity to one another. This again allows for a tremendous degree of control and makes it possible to create very subtle transitions from one colour or tone to another, ideal for suggesting form.

Density and form: In the rectangular shape, depth of tone and colour has been achieved by increasing the density of the cross-hatching. In the circular object, curved cross-hatched marks that follow the shape of the object help to indicate its form.

Optical mixing: Where one colour is cross-hatched over another, the colours can appear to 'mix', even though they are unmixed in the traditional sense of the word. Several colours can be used one over another to bond up complex colour mixes.

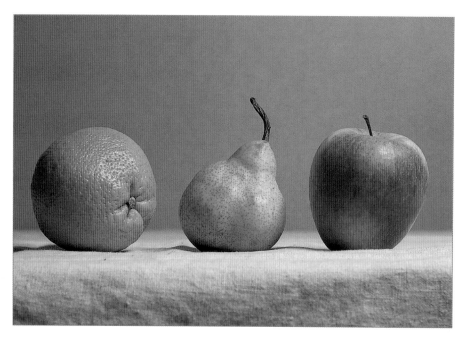

PAINTING THE ORANGE, PEAR AND APPLE

The purpose of this exercise is to show you how purely linear strokes can be combined and woven together to create both form and complex colour combinations that are mixed by the eye and not physically on the support.

1 Sketch out the composition in simple, basic shapes, with colours that approximate those of the objects being drawn – orange for the orange, light green for the pear and cadmium red for the apple. Use burnt umber for the stem of the fruit and ivory for the tablecloth. If you need to redraw do not worry, since subsequent applications of pastel will cover up any of your mistakes.

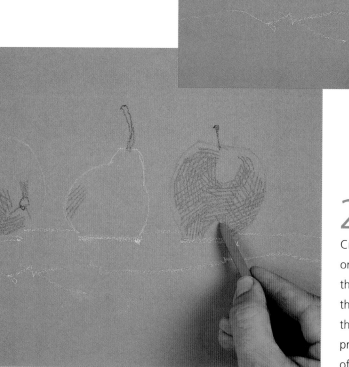

2 Begin building up the cross-hatching using the cadmium red. Cross-hatch the area in shadow on the orange, add a few hatched strokes on the shaded side of the pear to pick up the reflected colour from the orange, then cross-hatch the apple. As this is predominantly red, cover more or less all of the fruit with cross-hatching.

3 Now subdue areas of red on the apple with the orange pastel and add a few hatched orange strokes to indicate the reflected colour of the orange on the green pear. Establish the bulk of the orange by working orange hatching into the red to create the impression of a darker tone of orange.

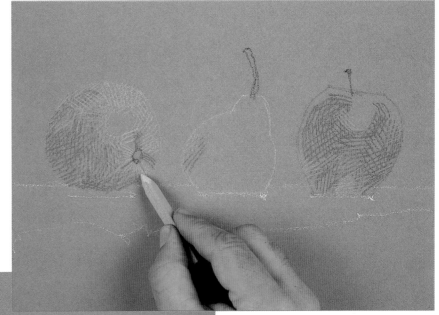

4 Next, add carefully hatched light green strokes across the top and sides of the apple together with a small area of green at the base. Use the same green to block in the pear, carefully considering the direction of these strokes so that they follow its form.

5 With mid green, a dab of light green and burnt umber, create the green stalk end of the orange. Using burnt umber, draw a simple line beneath the orange to indicate the cast shadow and rework the shaded side of the orange. Change to the white pastel and indicate the highlighted area with a combination of cross-hatched lines and small dots or dabs.

6 Move on to the pear and, using burnt umber, put in the colour of the stem and again make a simple mark at the base of the fruit to indicate its shadow. Make a few hatched lines of burnt umber on the side of the pear, followed by further work with the mid green and, for the darker tones, dark green. Paint the highlight in the same way as you did on the orange, then subdue the green of the pear by careful cross-hatching using the light orange pastel.

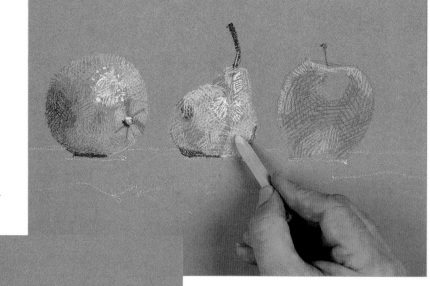

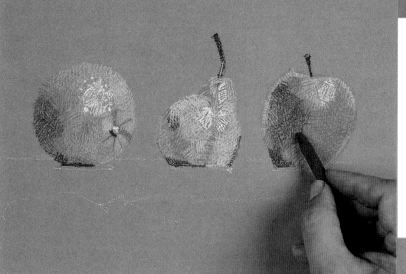

7 Treat the apple in the same way, using light orange and white to develop the highlight and areas of burnt umber to darken the side of the apple facing away from the light source.

8 Block in the tablecloth with the ivory pastel, indicating the parts of the cloth catching the light with denser cross-hatching. To create the cast shadows of the fruit, leave the colour of the support to show through.

9 Develop the colours and tones of the tablecloth by using Payne's grey in the shaded areas and white cross-hatched across the areas that are in the light. The background is simply the support colour.

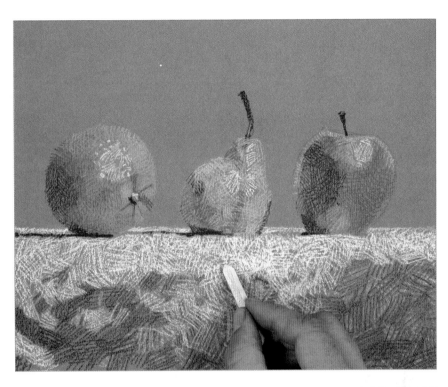

10 The finished image demonstrates how complex combinations of dense colour and tone can be created by the careful application of pastel in just a series of cross-hatched lines. The result is a crisp, clean image using a technique that is quick, simple and infinitely controllable.

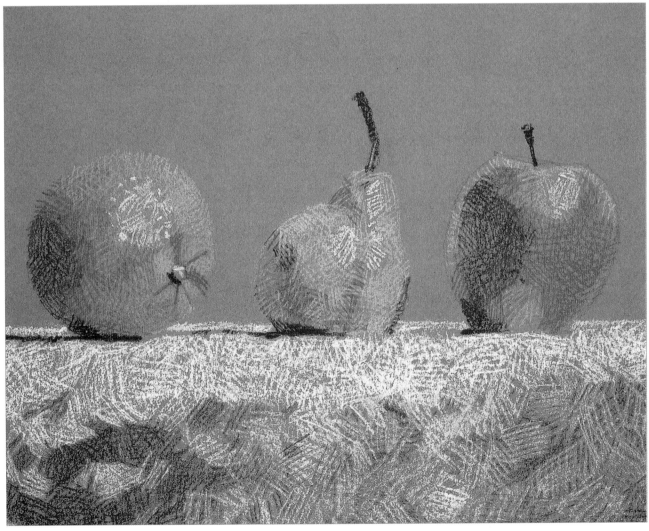

Step 4
impasto

focus: melon and pomegranate

Materials

28 x 38 cm (11 x 15 in) light brown
 pastel paper

Fixative

Large torchon (paper stump)

Hard pastels:

- *Cadmium red*
- *Light green*
- *Ultramarine*
- *White*

Soft pastels:

- *Cadmium red*
- *Burnt sienna light*
- *Burnt sienna*
- *Burnt sienna deep*
- *Grey green*
- *Ivory*
- *Black*
- *Mid green*
- *Light green*
- *Lime green*
- *Cerulean blue*
- *Payne's grey*
- *Raw umber*
- *Light raw umber*

Impasto without an underpainting:
Thick pastel can be applied without a
prior underpainting, but this often
results in a lack of colour depth as the
support colour may show through more
than is desirable.

In Italian the word *impasto* means dough, which gives a clue
to the type of painting it is employed to describe – thick
applications of pigment which in the case of oils, for example,
may even be three-dimensional. The term impasto is also used
to describe dense and heavy applications of pastel although
these, needless to say, will lack the thickness and tactile
qualities of heavy applications of paint. Nevertheless, they
can add texture as well as vibrant colour.

WORKING WITH IMPASTO

In order to make heavy applications of pastel you will need a support
that has sufficient tooth, or texture, to hold the pigment. Papers and
boards designed for pastel are ideal, as are rough papers intended for
watercolour. You can begin the work by applying the pastel marks thickly
from the outset, gradually placing marks and colour next to one another
and piecing the image together as you would a jigsaw. Placing marks side

Impasto over an underpainting: Working over an underpainting which modifies the support colour can result in greater depth and intensity of colour.

by side in this way is advisable because it can be quite difficult to place a second thick pastel mark over an earlier one – the initial mark will have filled the texture of the support with pigment, making it difficult for the pigment of the second mark to take hold. It will skid over the first mark, failing to deposit much colour, and what colour is left behind is often indistinct as it will have mixed a little with the pigment from the first mark.

However, it is much better to establish the image using a thin underpainting (see pages 22–23) to put in the general shapes, colour, tones and composition. Once this has been fixed it will act as a very good guide for the impasto which, because of the underpainting, can often be applied at this stage with a degree of looseness and flair – both very attractive, if elusive, qualities in the best of pastel paintings. Where you need to make corrections you can flick over the area with a rag or a stiff bristle brush. Alternatively, scrape away the pigment with the blade of a craft knife – which is in fact a technique in itself, known as sgraffito, that can be used to describe a range of textural effects (see page 75).

Where you are working with a strongly coloured support, underpainting first also has the advantage that the colours of the impasto layer will tend to have a greater density and appear stronger as they will not be modified by the support showing through.

PLANNING YOUR PAINTING

To minimize mistakes when you are working with impasto, spend time considering how the image is to be put together and in what order, so that the impasto application is clean and precise and, wherever possible, made in a single layer of pigments. Keep blending of the impasto layer to a minimum and try to use neat colour from a single pastel in any one area. This will keep the colours bright and prevent the muddy mess that can result from overworking. Once you have finished you can give the image a coating of fixative, though this will have the effect of dulling the colour. Many pastel artists fix the work before they place on the lightest colours and highlights in order to retain their brightness.

Fixing impasto: Impasto pastel paintings smudge easily, so fixing is often a necessity. However, fixative dulls the colour slightly – especially in the case of lighter colours, as you can see in the left-hand yellow marking here.

PAINTING THE MELON AND POMEGRANATE

Both of these striking fruits are ideal to illustrate how building up firm applications of pastel produce impasto effects that show off their strong, vivid colours. In painting them, you will also have the chance to try your hand at textural effects that describe the pattern and surface of each fruit.

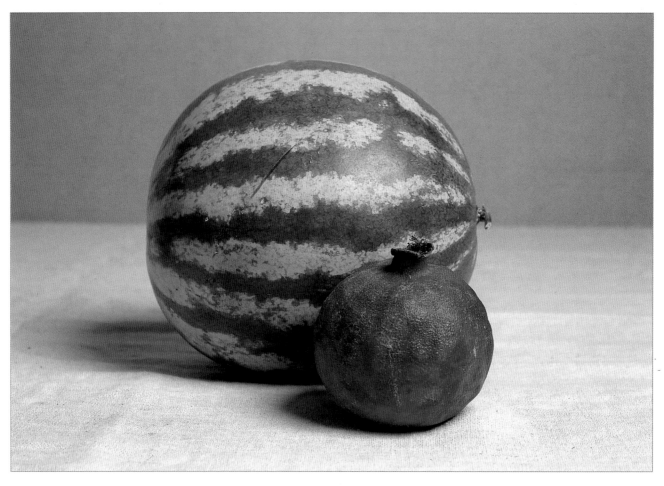

1 There is no need for an underdrawing as the shapes are very simple and basic. Begin by taking a short length of hard cadmium red pastel and, using this on its side, block in the shape of the pomegranate.

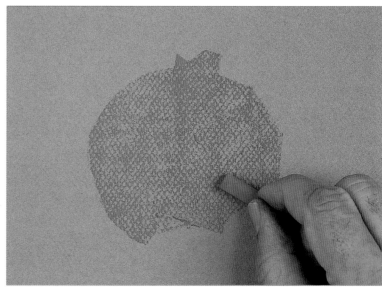

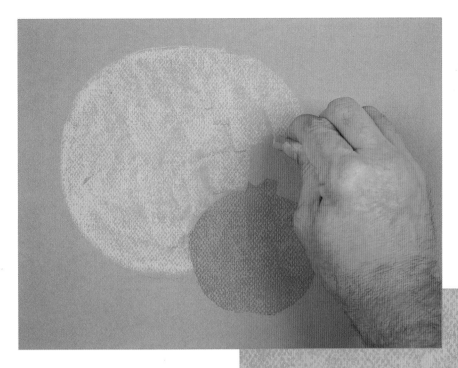

2 Next, take a hard light green pastel and in the same way block in the shape of the melon, positioning it relative to the pomegranate.

3 With a hard ultramarine pastel, block in the shadow of both the pomegranate and melon, then use a white pastel to establish the light-coloured tablecloth.

4 This simple underpainting will provide the foundation for the subsequent impasto, so all loose pastel dust needs to be removed. First push the pigment well into the tooth of the support with the large torchon, then remove the excess dust by taking the support outside and shaking it. Next, give the image a coat of fixative.

5 For the impasto, switch to soft pastels. Use precise, firm strokes to apply cadmium red, burnt sienna deep, burnt sienna and burnt sienna light to the relevant areas on the pomegranate. Overlay black in the shadow areas with touches of grey green and use ivory for the highlights.

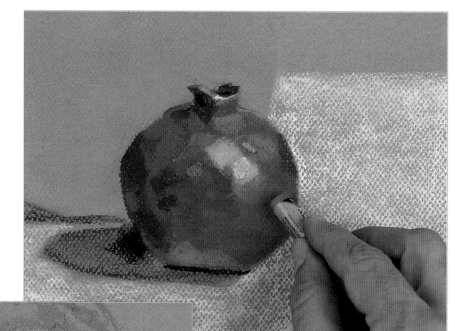

6 Establish the pattern on the side of the melon with mid green, then block in the darker areas of pattern with grey green.

7 Use light green on the lighter pattern together with touches of lime green on the end facing the light and around the reflected highlight. Apply cerulean blue to represent the colour of the reflected daylight.

8 Apply raw umber around the cast shadows and strengthen them with touches of Payne's grey and black. Paint light raw umber and ivory across the tablecloth, carefully working around the fruit and their shadows.

9 Finally, strengthen the background colour using a stick of raw umber on its side.

10 This relatively simple and straightforward image shows how impasto pastel can be applied cleanly and simply to produce a highly colourful image that does seem to possess a certain tactile quality without the colours becoming muddled and the surface overworked. The image can now be fixed, but do be aware of the slight colour shift that will inevitably occur.

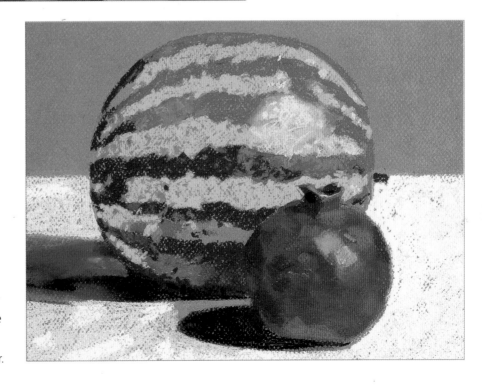

Step 5
layering and blending

focus: pears

Materials

24 x 32 cm (9½ x 12½ in) light brown
 pastel board

Soft bristle brush

Fixative

Torchon (paper stump), optional

Hard pastels:

- *Light green*
- *Mid green*
- *Olive green*
- *Dark green*
- *Lime green*
- *Burnt umber*
- *Vandyke brown*
- *Payne's grey*
- *Ivory*
- *Yellow ochre*
- *Raw umber*

Pastels are like any other painting material in that images can be built up in layers and colours blended together, except that unlike watercolour, acrylic or oil paint, the applied colour is dry. This has several advantages, not least the fact that there is no hanging around either in the short term or, in the case of oil paint, the long term waiting for the image to dry so that work can continue. This makes pastel an ideal material for working on location.

WORKING WITH LAYERS

As you have already discovered, a pastel painting invariably consists of a series of layers. The initial layer establishes the foundation, providing a guide for subsequent work; next the image is developed using heavier applications of pastel that block in and strengthen colour and tone, then detail is added. Working in this way prevents you from becoming bogged

Blending with your finger: Your finger is the easiest tool to use for blending. Make sure that your fingers are dry and grease-free and the resulting blends will be smooth and effortless.

some pastels may have been made by combining as many as six different pigments, you can see that if you blend together two or more pastels the number of blended pigments could run into double figures.

However, when you are working with a limited range of colours, blending two of them together is often the only way in which you can achieve the colour you want. In this case, restrict any blended work to the initial layers that establish the composition and use applications of single pastel colours to the final layers and for detail.

Blending is nevertheless a useful technique for softening and blurring edges where one colour is adjacent to another. You can use paper towels, cotton-wool buds, brushes or torchons to blend colours together, but the quickest and easiest tool to use which is always to hand is a dry fingertip.

Using a torchon: A torchon is tailor-made for blending and its point makes it possible to blend small or difficult areas. You can also use it for applying pastel by simply rubbing the pastel on the torchon or by picking up pastel dust from elsewhere on the support.

Making a torchon: Torchons are very inexpensive to buy, but you can improvise a home-made one by rolling a strip of newspaper to create a cone.

down with detail in the earlier stages of the work. Your aim is to bring each area of the image along at the same speed, finally adding detail and highlights which bring the image to life. If you do not want the layered elements to mix with one another you will need to apply a layer of fixative as each stage of layering is completed.

THE PRINCIPLES OF BLENDING
Blending is best kept to a minimum, for blended pastels lose their brilliance as a result of the way in which pigment colours mix together. When the coloured light waves of the spectrum (the colours of a rainbow) are combined, the result is white light, known as additive colour mixing. However, if the same seven pigment colours are combined (subtractive colour mixing), the result is a muddy, almost black mess. Therefore, the fewer pigment colours that are mixed together the better – and as

PAINTING THE PEARS

This simple still life of two pears, 'framed' by the paper bag they were bought in, will show you how to build a pastel painting in layers. You will also find out by experience how blending with your finger or other suitable tool can produce an image that has both tonal and colour graduations that, if pushed to their limits, can almost resemble a photograph.

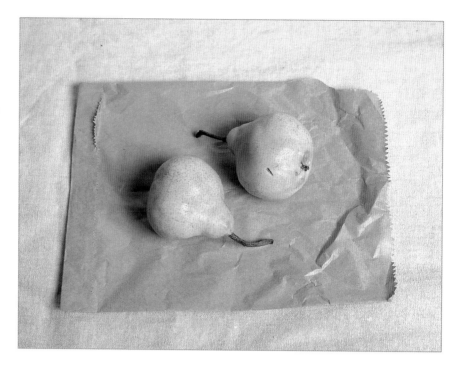

1 Begin by lightly drawing the position and shape of the two pears and the paper bag, using light green for the pears and burnt umber for the stalks and the bag. Draw in the shape and extent of the shadows, also with burnt umber.

2 Use light green to establish the colour of the pears, exerting light pressure to avoid too heavy a build-up of pigment dust. You will find that the type of textured support used here accepts the pastel colour very easily.

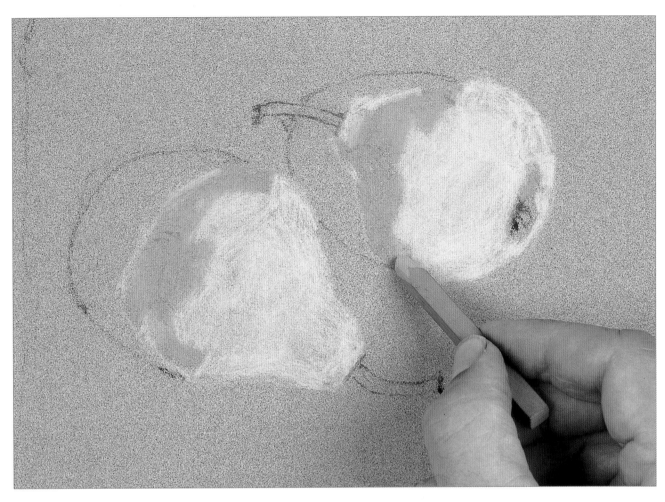

3 Apply mid green in exactly the same way to the side of each pear that is in shadow.

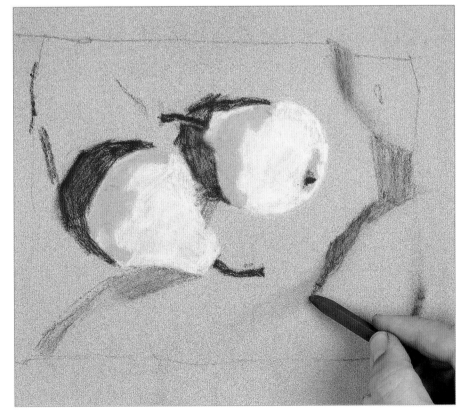

4 Using Payne's grey, paint in the shadow cast by the bag on to the tablecloth. Block in the colour of the stalks and the cast shadow of each pear with burnt umber then, with the same pastel, indicate the darkest shadows on the crumpled surface of the paper bag.

5 Draw around the shape of the bag with ivory to establish the colour of the tablecloth, making small dashes of colour along the serrated edge of the bag. The overall colour or look of the bag is represented by the colour of the support.

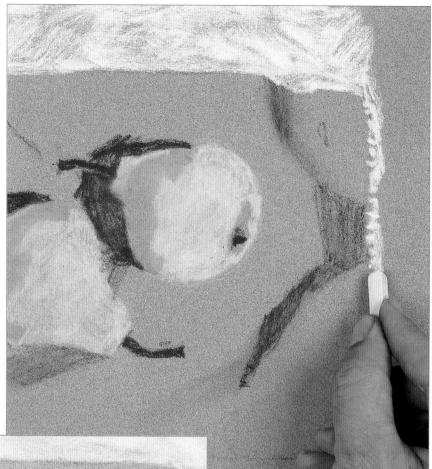

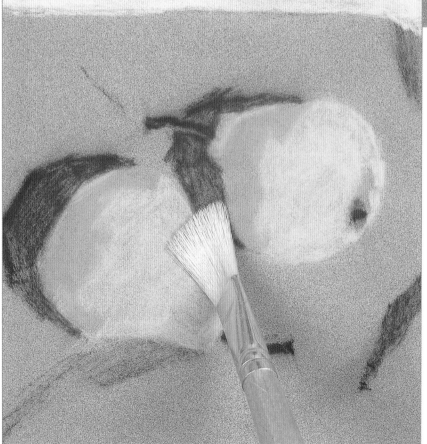

6 The overall basic colour scheme is now established and you need to remove the excess pastel by carefully brushing over the image with a fairly soft bristle brush. This process also serves to blend the colours together slightly, blurring the edges nicely between one colour and the next. You can now fix the painting.

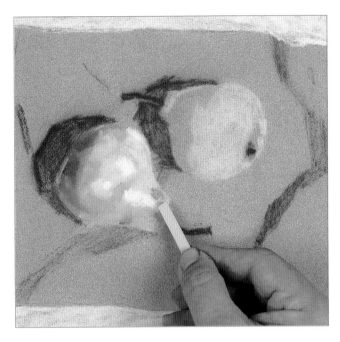

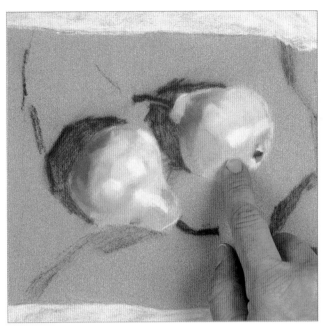

7 Develop the colours on each pear using light green, mid green, olive green and dark green, with lime green for the highlights and touches of yellow ochre.

8 The colours on the pears now need to be softened and blended carefully together. Whether you use a torchon or your fingers is a matter of personal choice, but you will find that you can achieve a softer blend with your fingers.

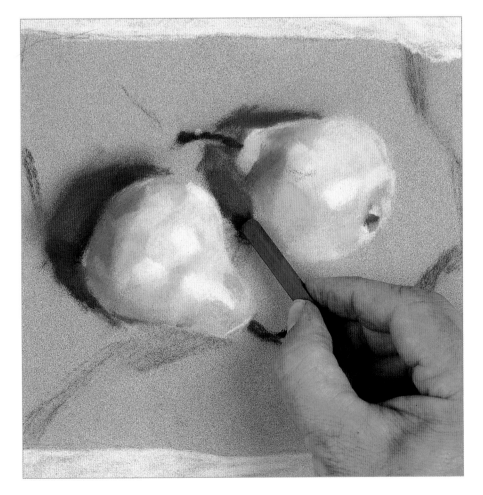

9 With Payne's grey and Vandyke brown, put in the darkest shadows. This has the effect of instantly adding depth to the image and the pears will seem to lift from the support surface.

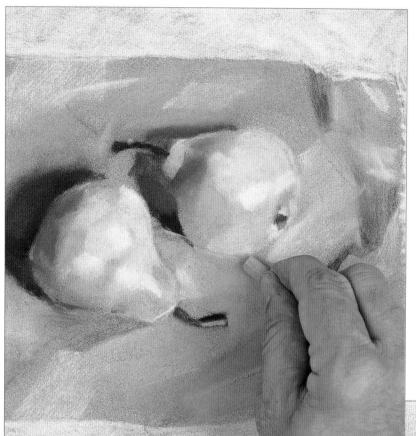

10 Now work on the crumpled paper bag, using ivory, raw umber and yellow ochre. Rather than applying the colour from the end of the pastel, use the edges of short lengths of hard pastel to make crisp angular marks that echo the shapes made by the creased paper.

11 With a few simple strokes, add highlights to each pear in light lime green.

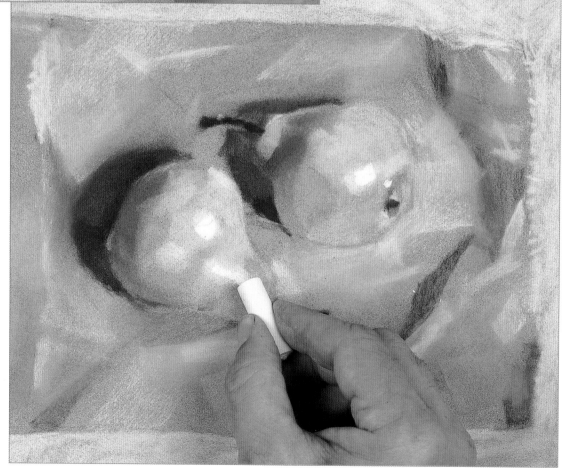

12 To add interest and increase the sense of realism, draw in the weave of the tablecloth with ivory pastel, though in reality it is not nearly so well-defined.

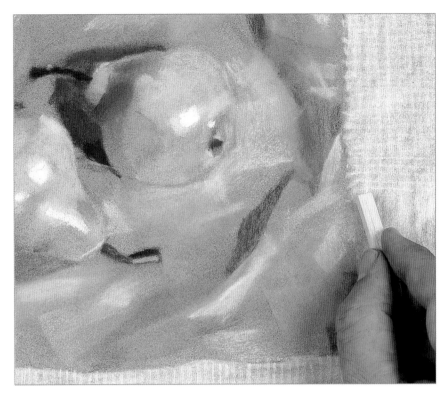

13 In the finished image you can see how simple blending can create gentle transitions between colours and tones, achieving a strong feeling of realism while avoiding muddy and confusing colour.

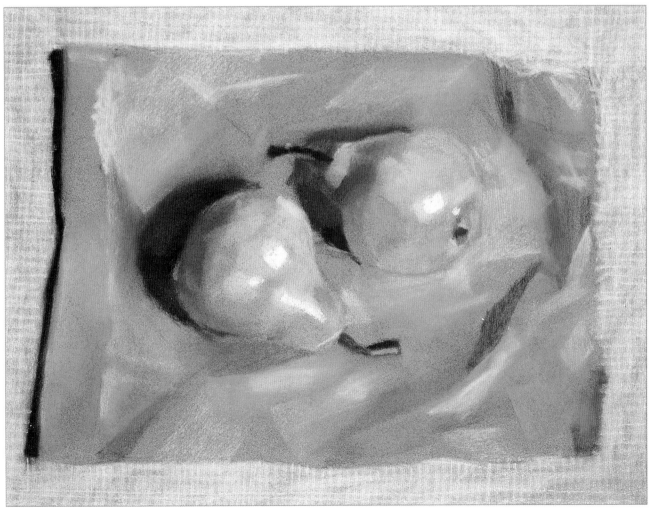

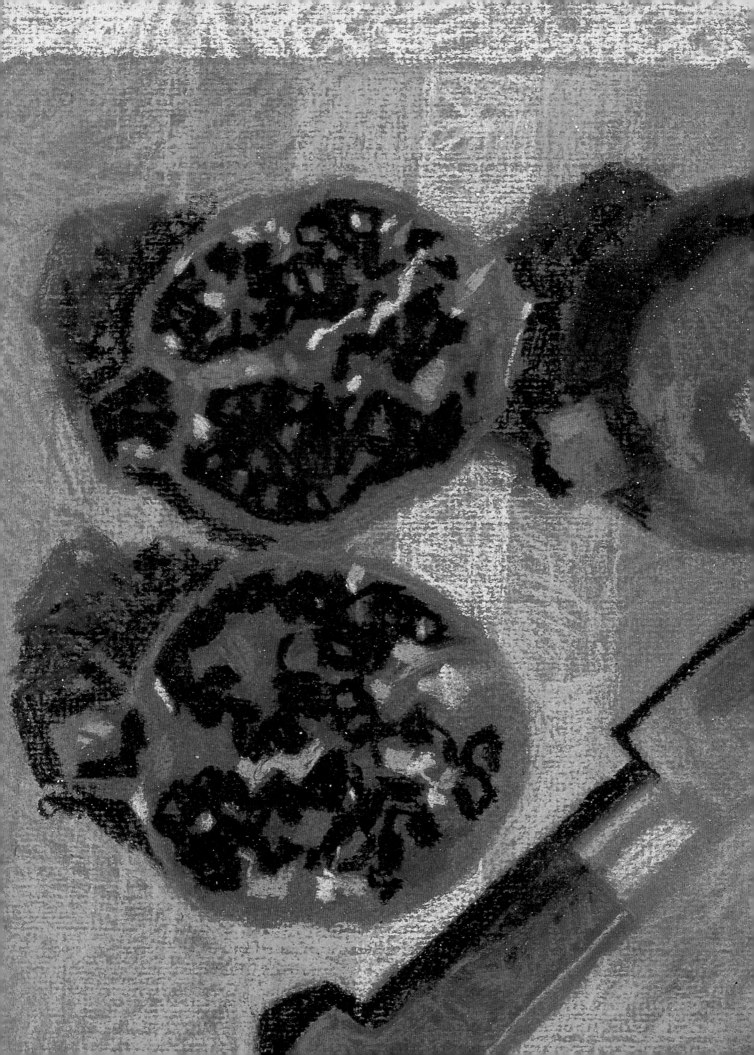

Step 6
textural techniques

focus: pomegranates

Materials

21 x 29 cm (8½ x 11½ in) dark brown
 pastel paper

Fixative

Hard pastels:

• *Raw sienna*

• *White*

Soft pastels:

• *Cadmium red*

• *Dark red*

• *Burnt umber*

• *Yellow ochre*

• *Ivory*

• *Light cool grey*

• *Burnt sienna*

• *Light violet*

• *White*

• *Black*

The ability to represent the surface qualities of your subject is very important, as they make a large contribution in describing its true character. Smooth, pitted, rough, reflective, ribbed and granular are all words you might use to describe a surface, but how do you visually represent them? Pastel supports already have a surface texture which is there primarily so that the pigment has something to hold on to. This texture can be used to good effect, but if it is allowed to dominate it can detract from the subject itself.

The clever pastel artist is able to disguise this overall texture by using a range of techniques and a variety of different marks. There are two ways to approach this, either by painstakingly drawing and painting the visual qualities of a surface, capturing it in an almost photographic way, or by more quickly capturing just the essence of that surface. In reality, artists invariably combine both approaches in the same image.

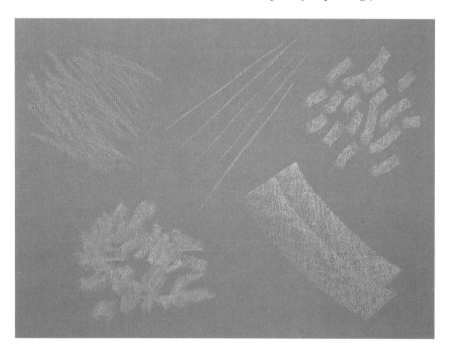

Varying your marks: You can make different marks by varying the way you hold the pastel. These marks have been made using the end, the edge and the side of a hard pastel.

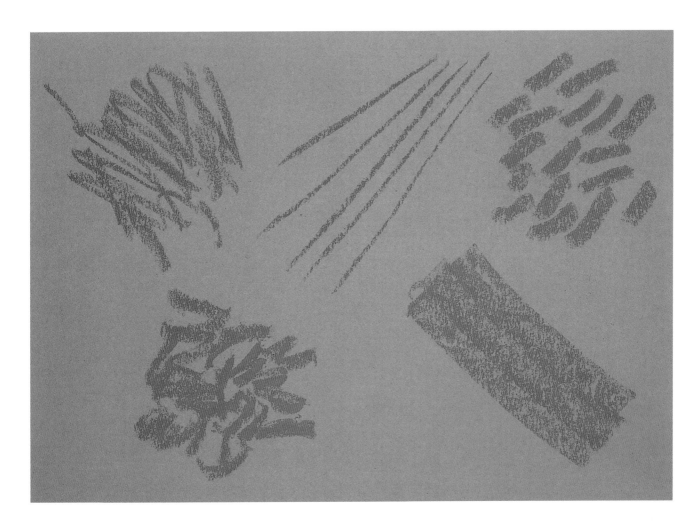

MAKING THE MOST OF MARKS

Learning to apply your pastels in a variety of ways is essential. A broad stroke using the side of a pastel will read very differently to a mark made using the end, as will a delicate, slowly made stroke compared to a fast, heavy stroke made with determination and impatience. A softly blended area will contrast with one that is loosely and coarsely painted, while linear strokes will describe a different texure to that suggested by dots or dashes.

Scumbling is a useful technique where one colour is painted loosely over another. Apply the colour being scumbled in loose, multi-directional and preferably wide, light strokes that allow elements of the base colour to show through – a technique known as glazing. You will find you can build up several layers

Frottage technique: Using frottage on a thin support has picked up the texture from a rough plank of wood.

Using different pastels: Here the same range of marks has been made, this time using a soft pastel.

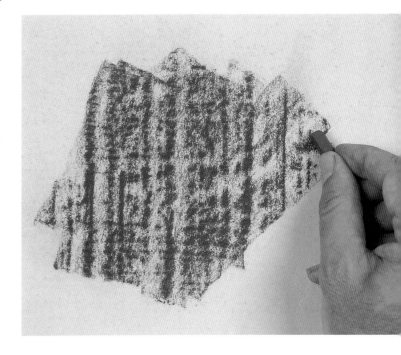

of different-coloured pastels in this way. Broken colour is a similar technique, but the marks are heavier and more precise, with gaps left between them.

A good way to capture the quality of an edge is to tear or cut a piece of paper and place it on the image to act as a mask. Work the pastel up to and over the mask edge; when you remove the mask, the image of its edge will remain. Alternatively, when you want a straight edge, simply work up to the edge of a ruler.

Frottage is a texture-making technique that works only with thin supports. Place a textured object beneath the support, apply the pastel to the support surface and an image of the texture below will be transferred onto the support.

All these textural effects are made by applying pastel, but you can also create textures by removing it (see pages 74–75).

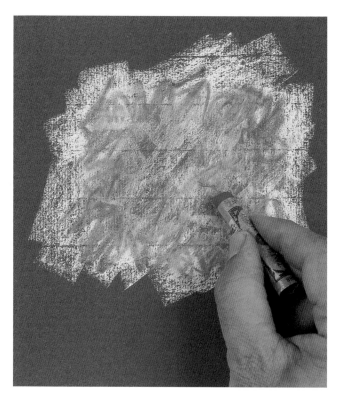

Scumbling: Here, blue pastel has been loosely scumbled over white pastel.

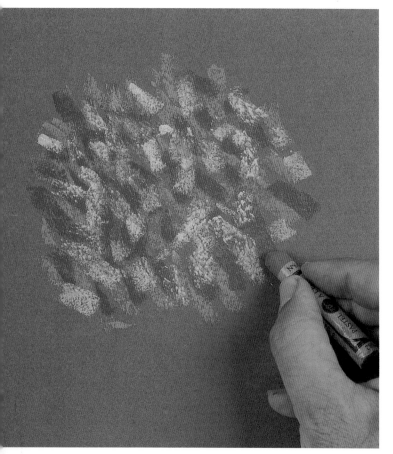

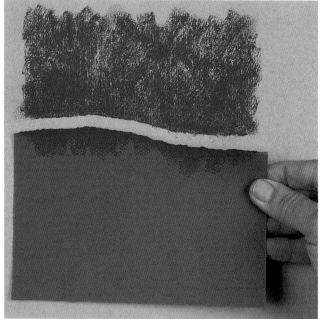

Masking: Working blue pastel over a torn paper mask has created an interesting edge quality to the painted area.

Broken colour: Orange, yellow and red pastel have been applied in turn to create a broken colour effect.

PAINTING THE POMEGRANATES

Describing the surface of objects is very important, both in adding interest to an image and suggesting their tactile qualities to the viewer. This exercise shows how combining a few different methods of pastel application will help to produce a more complex and arresting image.

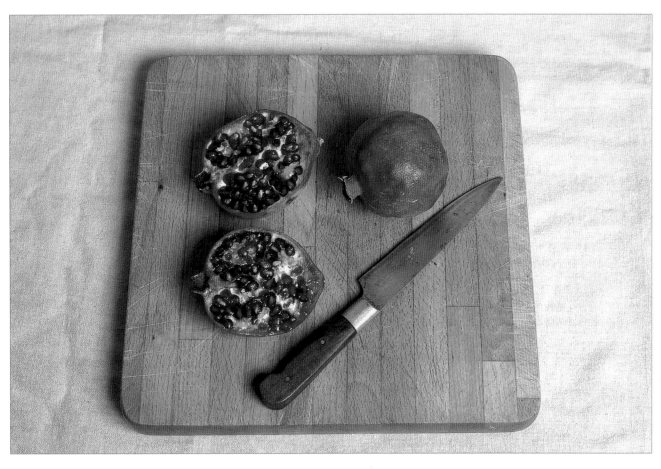

1 With a hard raw sienna pastel, sketch in the shape of the pomegranates, the knife and the board.

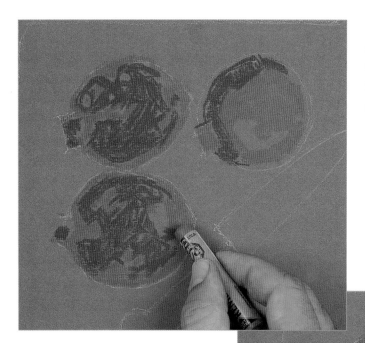

2 Paint the bright red areas on the pomegranate skin with cadmium red, then turn to dark red to block in the area of seeds at the centre of the cut pomegranate and the darker skin of the uncut fruit.

3 Establish darker patches around the seeds and the handle of the knife with burnt umber pastel, then scribble a little of the same colour on the blade of the knife to represent the dark reflected colour from the pomegranate.

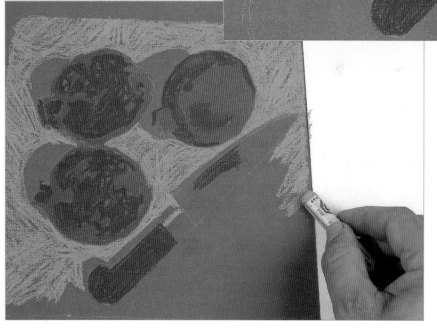

4 Block in the chopping board with yellow ochre, working carefully around the fruit and the knife. Use the straight edge of a sheet of white paper as a mask so that you can scribble the colour on quickly and loosely without straying out of the area of the board. Leave the support to show through and represent the cast shadows of the fruit and the knife.

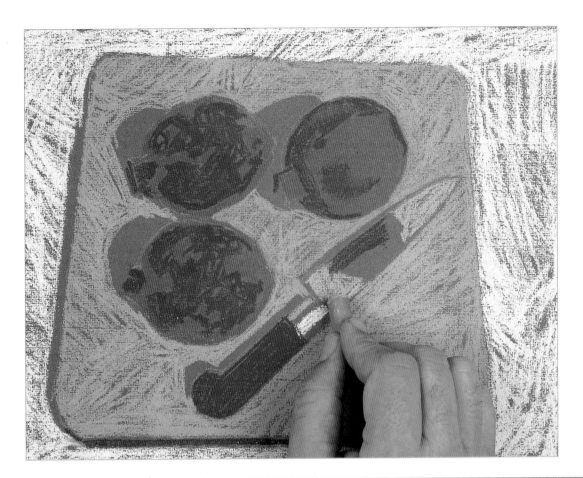

5 With the ivory pastel, block in the light cloth, allowing the support to show through as before for the shaded area at the edge of the chopping board. Use ivory for the reflection on the knife handle and a light cool grey for the blade of the knife. At this point you can brush over the image to remove excess pastel dust and give it a spray of fixative.

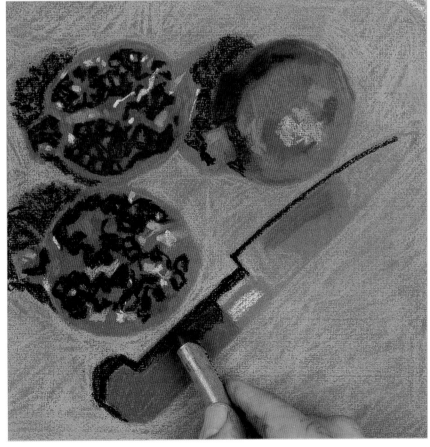

6 Repaint and strengthen the skin colour of the pomegranates with cadmium red and burnt sienna. Pick out the highlights on the seeds and the side of the fruit with touches of light violet and white, then block in the shadow areas around the fruit and the knife with black. Use black to paint in the dark seeds and the darker colour on the handle of the knife.

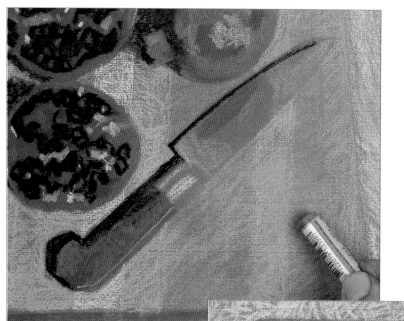

7 Add burnt umber to the shadows and to the handle of the knife. Indicate where the light hits the edge of the knife handle with a delicate line of yellow ochre and scribble a little burnt sienna onto the knife blade to increase the sense of reflected colour. Next, paint the wooden chopping board with combinations of yellow ochre, burnt umber and burnt sienna to block in the individual strips of wood that make up the board. Scumble these colours lightly over the base colour, allowing it to show through in places.

8 Repaint the cloth with light cool grey, applying it as an open scribble over the initial ivory underpainting.

9 With the ivory pastel, dot in the brass rivets on the knife handle and draw several fine lines across the board to represent cut marks. Work the same colour over the cloth in open marks that allow the previous layer of pastel to show through.

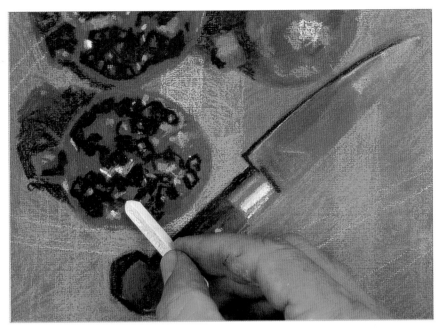

10 Finally, add highlights to the knife handle and the juicy seeds with hard white pastel.

11 The finished image shows how using a few alternative approaches and mark-making techniques in the same painting helps to distinguish between the different surface textures and characteristics.

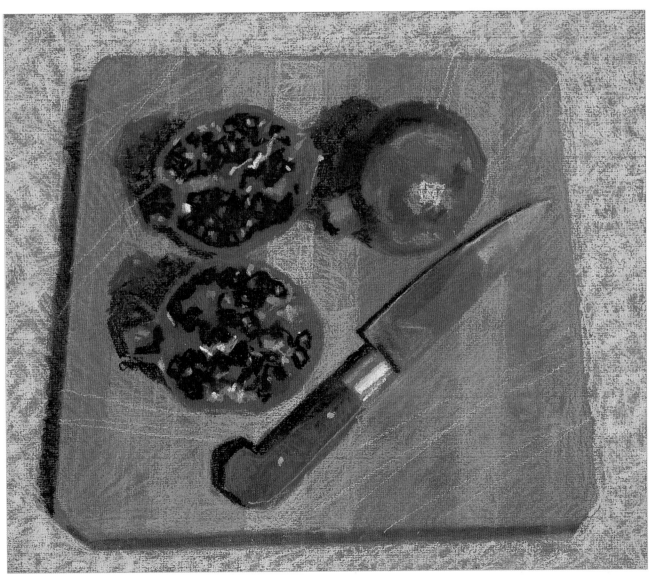

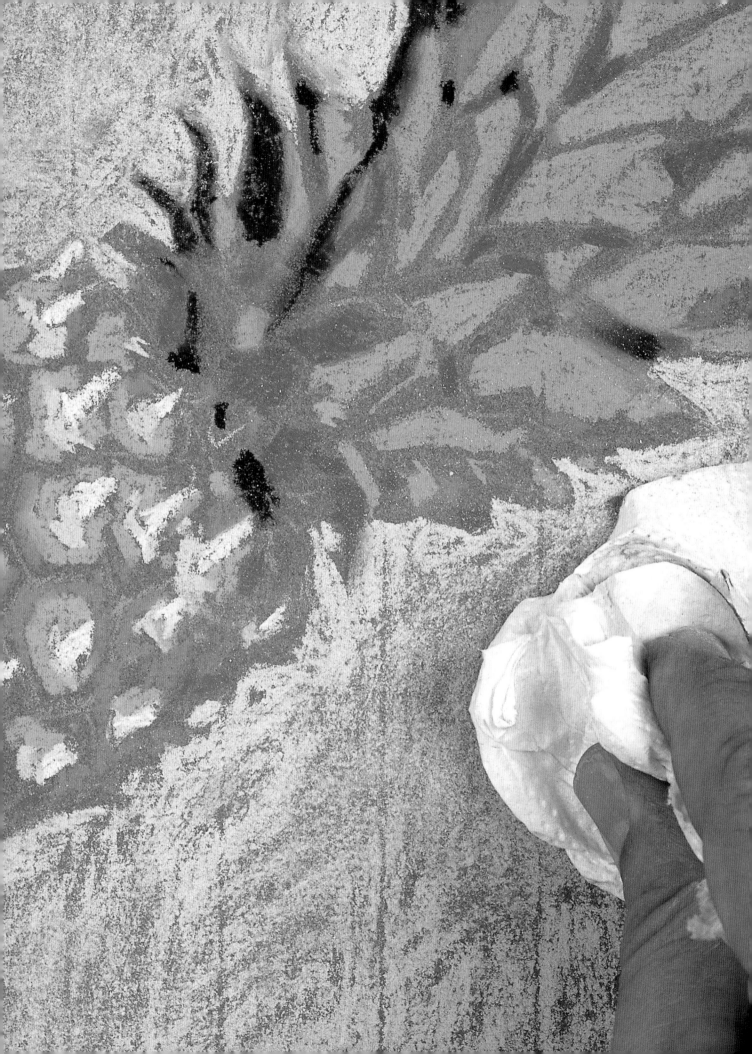

Step 7

erasing and sgrafitto

focus: pineapple

Materials

28 x 38 cm (11 x 15 in) mid green pastel paper

Scalpel or sharp-pointed craft knife

Fixative

Hard pastels:

- *Light grey green*
- *Ivory*
- *Yellow ochre*
- *Raw sienna*
- *Burnt umber*
- *Light violet*
- *Light green*
- *Mid green*
- *Dark green*
- *Oxide of chromium*
- *Dark warm grey*
- *Grey green*
- *Black*
- *Light warm grey*

With pastel, you can easily solve most mistakes by applying fixative and then reworking the problem area using more pastel. However, if the area to be repainted has already been heavily worked, further applications of pastel may not take well. The answer is to remove the pastel dust from the surface of the support first, which you can do in a number of ways.

If you have not already fixed the area, you can simply brush away the pastel dust to reveal the texture of the support. Precise areas can sometimes be removed by carefully dabbing a piece of masking tape onto the support to lift the pigment away from the surface. Keep using fresh pieces of masking tape until you reach a point where the area will accept

Removing pastel with an eraser: The sharp edge of a hard eraser will create linear patterns when drawn through unfixed pastel work.

Using a craft knife: The flat edge of a sharp craft knife blade will scrape away even very thick accumulations of pastel.

further applications of pastel. Dabbing a scrunched-up piece of tissue or paper towel works in a similar way but leaves behind a very pleasing 'marble' effect.

Erasers will lift lighter applications of pastel but they are of limited use on heavy applications; the eraser picks up pigment initially but quickly becomes dirty and clogged, then simply pushes and smears the pigment into and across the support, making the problem worse. Consequently, you should use an eraser with care.

On both fixed and non-fixed areas, heavy applications of pastel can be removed using the sharp edge of a craft knife. Pulled sideways across the support, it will scrape away most of the pastel back to the support surface. The process can sometimes flatten the texture of the paper, but if you spray the area with fixative before you rework it you will find that small particles of resin are deposited on which pastel takes quite well. Ensure that you do not cut into the support by mistake.

MAKING TEXTURAL MARKS

Removing pastel from the support is also a very successful way of creating textural marks. You can employ all of the techniques described above, but perhaps the most successful are those where the pastel is scratched into with sharp instruments – a technique known as sgraffito. This is used to reveal areas of the support or a pastel colour that has been fixed.

You can vary the effects you can get with sgraffito by working dark over light colours, or by using several multi-coloured layers all of which have been successively scratched into, fixed then worked over with more pastel. However, perhaps the greatest benefit of sgraffito is that it allows you to draw very fine linear marks, which can be difficult to achieve with pastel. This is a useful technique for highlights and for creating textural effects in a landscape, such as grass or the linear patterns of tree barks. As with the scraping technique used for corrections, take care only to remove the pastel and avoid cutting into the support by scraping the blade sideways.

Linear marks with a scalpel: The sharp point of a scalpel will draw a very fine line through unfixed pastel.

PAINTING THE PINEAPPLE

A pineapple is a surprisingly difficult thing to draw well. This one, laid on a simple tablecloth, makes a subject on which to illustrate sgraffito techniques. These linear marks, made by scratching through the loose pastel dust, are ideal for describing the texture and pattern on the pineapple itself and the weave of the tablecloth. Such fine marks would be all but impossible to draw in pastel itself.

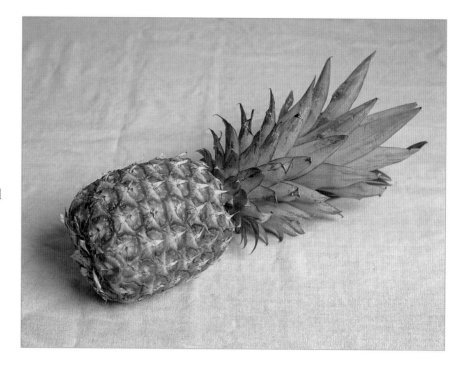

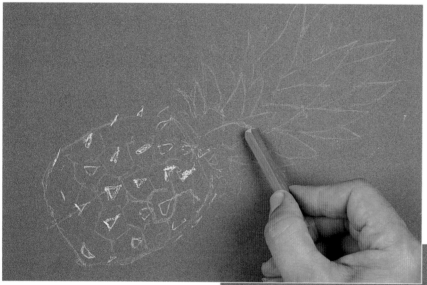

1 Sketch out the basic shape of the pineapple and its leaves, using an oxide of chromium pastel. Draw in the centre of each segment on the rough skin with ivory.

2 Develop the centre of each segment with further applications of ivory, yellow ochre and raw sienna.

3 Indicate the colours at the base of the pineapple with a combination of raw sienna, yellow ochre, burnt umber and light violet. Develop and block in the segments using a light and mid green.

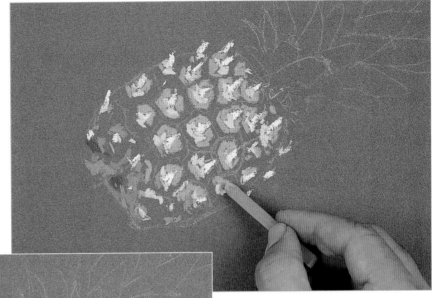

4 Next, add dark green touches around the edge of the segments.

5 Paint in the brighter topmost leaves with light green and a little mid green, then block in the rest of the leaves with oxide of chromium.

6 Use dark warm grey to establish the shadow at the base of the fruit. Add small touches of grey green, dark green, dark warm grey and black to the parts of the foliage that are in deep shadow.

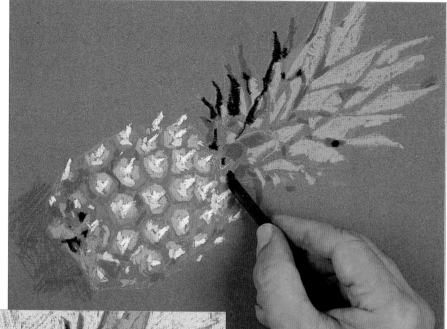

7 Block in the colour of the cloth in the background with light warm grey, working carefully around the shape of the pineapple and adjusting the shape of the fruit as you go should it seem necessary.

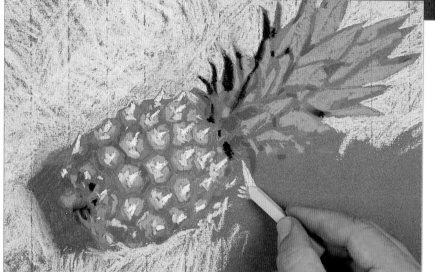

8 Lighten the background colour by carefully dusting off the excess pastel dust using paper towel, tissue or, if you wish, a bristle brush. Try not to disturb the unfixed pastel work on the pineapple itself.

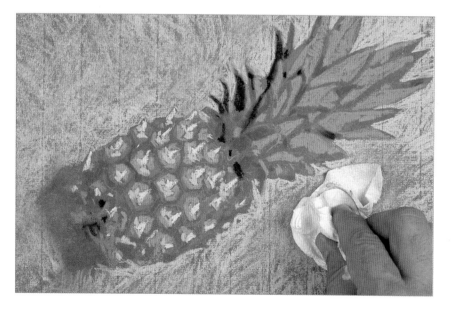

9 With a scalpel or sharp-pointed craft knife, scratch into the pastel on each of the segments to create a linear pattern that radiates out from each centre. Make the linear pattern on each of the leaves in the same way.

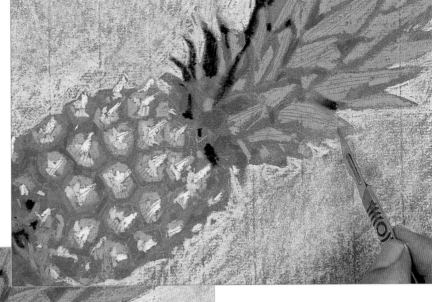

10 To complete the image, repaint the tablecloth with the ivory pastel then scratch a series of lines through the pastel to represent the weave of the cloth. Add touches of dark green to the foliage shadows and then fix the image.

11 The finished image shows how a few simple sgraffito marks give added interest and a touch of realism. As with most things it is better not to overdo the technique, but it does provide a solution whenever fine linear marks are required.

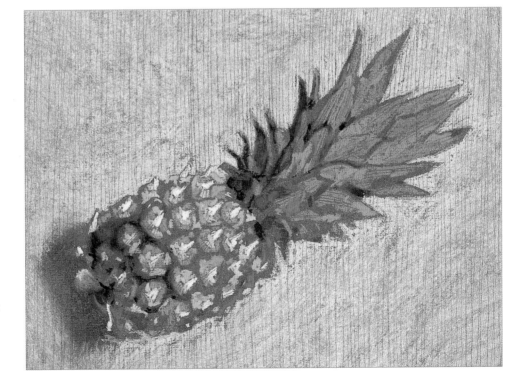

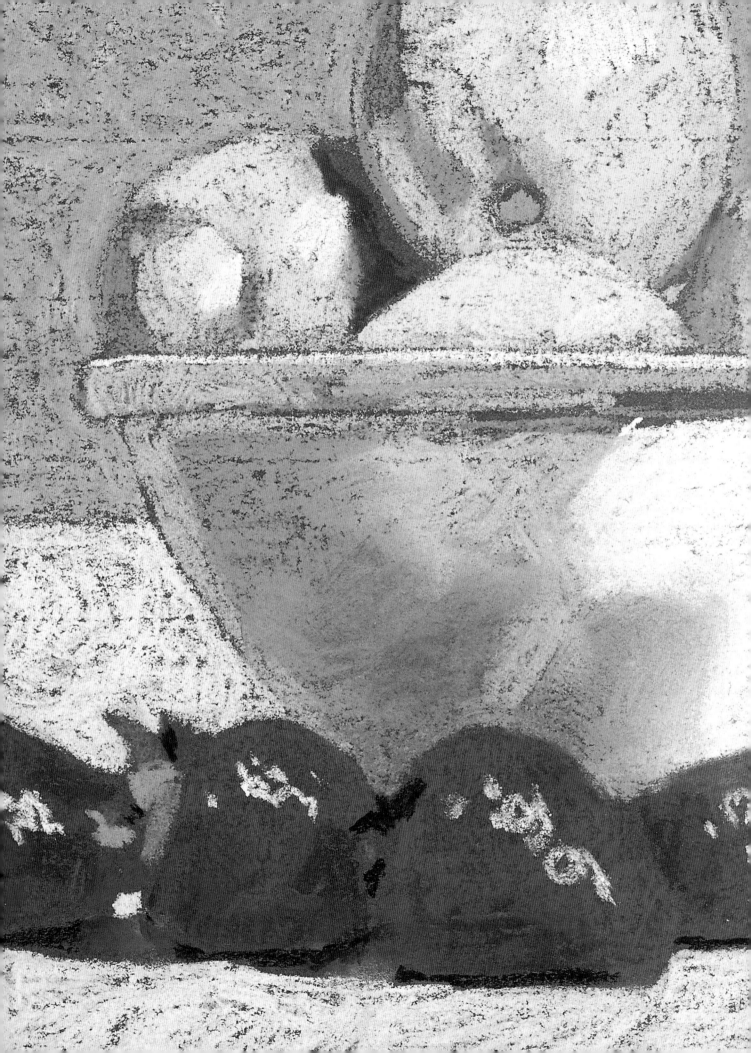

Step 8
support colour

focus: lemons and strawberries

Materials

25 x 33 cm (10 x 13 in) blue pastel paper

Hard pastels:

- *Raw sienna*
- *Yellow ochre*
- *Cadmium yellow*
- *Cadmium yellow deep*
- *Lemon yellow*
- *Light warm grey*
- *Warm grey*
- *Cool grey*
- *Dark cool grey*
- *Black*
- *White*
- *Ivory*
- *Light green*
- *Mid green*
- *Grey green*
- *Cadmium red*
- *Dark red*
- *Burnt umber*

The strongest influence on how your image will look comes from the colour and tone of your support, so you need to choose it very carefully. To see how the pastel colours that you plan to use will be affected, simply take a single pastel and make a block of that colour on several different papers; the variation in the applied colour will be remarkable. As a pastel artist, you can put this to very good use. Indeed, pastel paintings seldom look good when made on a white background; even bright colours look washed out and weak and the image tends to lack any real depth or substance.

CHOOSING A COLOUR

The first decision to make is whether the support colour should contrast or harmonize with the colours of your subject. Using a support that contrasts can make your pastel colours look much brighter than they might do otherwise – but take care with very bright support colours, which can easily dominate.

Choosing a support colour that harmonizes with the main colour scheme of the subject pulls all of the applied colours together. This type of support also cuts down on the work involved as you will find that you can allow its colour to show through and provide the overall mid colour or tone, using darker and lighter colours and tones to provide the shadows and highlights.

A wide choice: There is a large range of tinted and coloured papers available, made specifically for pastel artists.

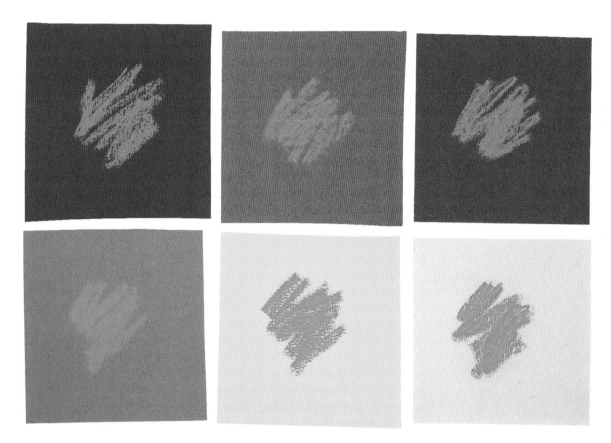

TONAL CONSIDERATIONS

Like bright-coloured papers, very dark- or light-toned papers can be difficult to work with. A mid-tone support is the easiest to use and will provide a good support on which to judge the lighter and darker tones of the subject. A large range of mid-toned, neutral-coloured pastel papers and boards is available, ranging from earthy browns, greens and blues through to dusty ochres and greys. However, while these will be the papers that you will tend to use most of the time, low-key (dark) subjects can benefit from being painted on dark-toned supports and conversely high-key (light) subjects may benefit from lighter-toned supports.

Remember that you can always tint your own support to suit your subject. Use Not surface watercolour paper, which has a slight tooth, and apply a wash of watercolour paint or thin acrylic paint. This does not have to be perfectly uniform, and in fact variations in the intensity of the colour will add interest. You can also colour the support using pastels, but it is important to avoid clogging the tooth of the support with pastel dust, so apply it sparingly.

Comparing different effects: The choice of support colour will have a marked effect on the way the colours you use are perceived. Here a light green appears to change colour when used on six different supports.

Tinting your own support: If you cannot find a suitably coloured support, try tinting a sheet of watercolour paper with either a watercolour or acrylic wash.

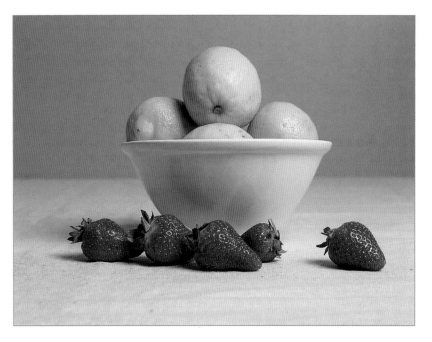

PAINTING THE LEMONS AND STRAWBERRIES

The lemons and strawberries are painted on a support that is deep blue in colour. This serves to intensify the yellow of the lemons and the red of the strawberries as the blue optically mixes with the colours of both, giving a slight green tinge to the lemons and a purple tinge to the strawberries. The white ceramic bowl also benefits from the slightly blue undertone present beneath the white and grey pastel.

1 Sketch out the composition using white for the bowl, red for the strawberries and yellow for the lemons.

2 Paint the lemons first, using raw sienna for the side of the lemon in shadow and cadmium yellow and cadmium yellow deep for the main overall colours.

3 Turn your attention to the white ceramic bowl, blocking it in with a light warm grey, a warm and a cool mid grey and white. Create the dark shadow beneath the rim by allowing the blue of the support to show through.

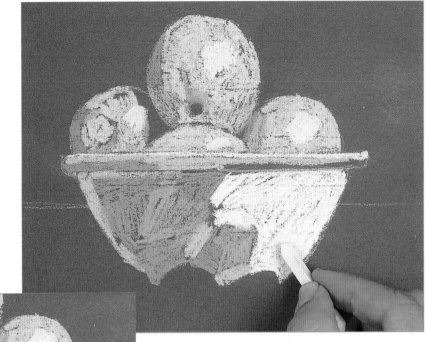

4 With touches of light and mid green, suggest the remains of the stalks on the strawberries. Paint the strawberries themselves using cadmium red and dark red.

5 Next, block in the background with yellow ochre, keeping the pastel work 'open' to allow the blue support to show through in places. Block in the tablecloth, using the same technique and a light warm grey pastel, 'cutting out' the shapes of the small leaves by leaving the colour of the support visible. At this point you can apply a coat of fixative to the image.

6 Return to the lemons, adding a touch of burnt umber into the shadows then repainting each lemon using cadmium yellow and cadmium yellow deep. Add touches of lemon yellow to the lit side of each lemon and to the lemon that is just peeking over the rim of the bowl, then put in each of the highlights with white.

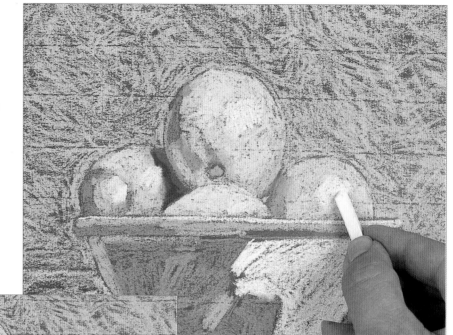

7 Using the same greys as before, repaint the bowl. Add a little dark red and raw sienna to the side of the bowl and, with your finger, carefully blend it into the surrounding grey. This represents the reflected colour of the strawberries.

8 Develop the small leaves with grey green and the mid and light green you used earlier. Repaint the strawberries with cadmium red as before, allowing the support and underpainting to show through in some places. This helps to represent the rough pitted surface of the fruit.

9 Scumble (see page 65) warm grey over the yellow ochre background and apply ivory over the tablecloth, using an open scribbling that allows the underpainting to show through in some places.

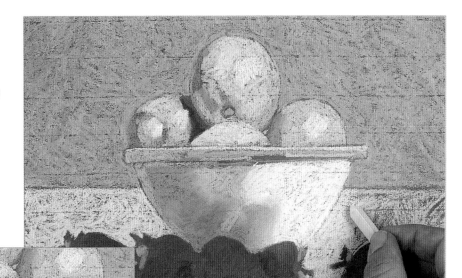

10 Finally, strengthen the shadows of the strawberries with touches of dark cool grey and black and add touches of white for the highlights.

11 The finished painting illustrates how the dark blue support helps to intensify the applied pastel colour and also shows through it, creating an overall colour harmony.

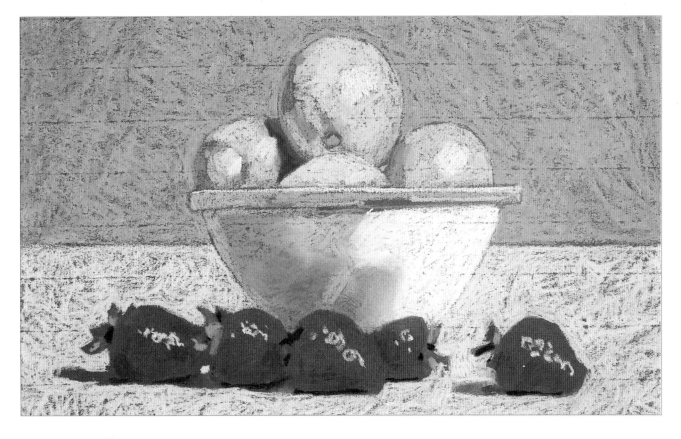

Step 9
composition

focus: arranging the elements

Materials

2 L-shaped pieces of card

2 bulldog clips

White drawing (cartridge) paper

Black pastel pencil

Composition is the term used to describe the design of your picture – the way in which all of the different elements are organized within the overall frame. A good composition is pleasing to the eye, well-balanced, and persuades the viewer's eye to move around the image in the way the artist wishes. All of the elements within an image can have a profound effect on the composition, including colour, tone, texture, shape, size and perspective.

FORMAT

The first thing to consider is the format, or shape, of the intended painting. This is very important, as the format has a direct influence on the composition and the way in which the viewer's eye moves across or around the piece.

There are three main formats: horizontal, which is a rectangle with the longest side running horizontally; vertical, a rectangle with the longest side running vertically; and square, where all sides are of an equal length. While both rectangular formats can be altered and stretched, the square format always remains square regardless of its size.

While there are no set rules as to which format should be used for a particular subject, with a horizontal format the eye is persuaded to move from side to side across the image, which makes it a favourite choice with landscape artists. In contrast, the vertical format encourages the eye to move up and down and is therefore popular with portrait painters – hence the description of these two formats as 'landscape' and 'portrait' respectively. The square format persuades the eye to move equally in all directions, ultimately concentrating on the middle.

If you are unsure about which format to use, you will find a viewing frame a useful aid. It is a simple matter to make one by cutting two L-shaped pieces of card through which you can look at your subject in different formats and sizes. Once you have made your initial decision, you

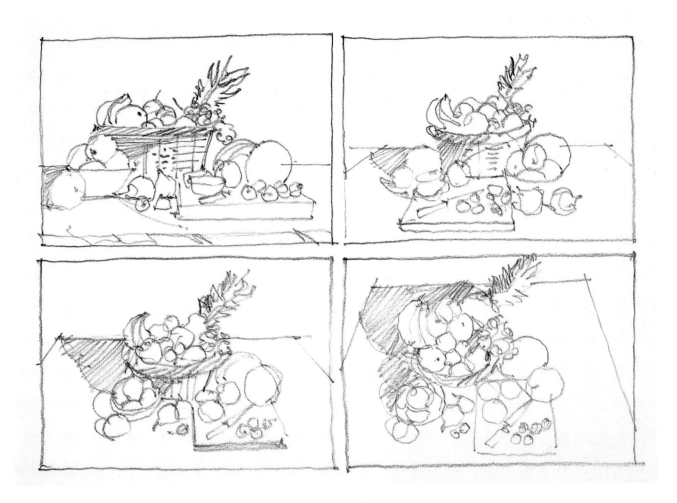

can hold the pieces of card together at the corners with two clips to make the shape stable, while you check the composition carefully before you start work.

VISUAL BALANCE

A good composition is visually balanced, meaning that no one part overpowers another. This is achieved by using 'point and counterpoint'. For example, a large, dark mass might be offset, or balanced, by a much smaller mass that is brightly coloured, or a large flat area by an intricate, highly textured or detailed area. Alternatively, you could use colour to balance texture, light to balance dark, or complex to balance simple.

LEAD-INS

Artists often use a device known as a 'lead-in' which is intended to act as a visual pathway to draw the eye into the image. Lead-ins can be visually literal, such as a roadway, a river or a fallen tree along which the eye

Making thumbnail sketches: Spending a little time on thumbnail sketches first is well worth the effort, as you will have your composition worked out before you begin the painting proper.

instinctively travels into the image. However, you can also devise them in less literal ways, such as a shaft of light or the perspective of an object.

USING THUMBNAILS

The best way to work out your compositional ideas is through a series of thumbnail sketches. These are just large enough to enable you to try out ideas of position and layout with enough information on colour, tone, scale and so forth to be visible. They allow you to examine a number of alternative compositions and make decisions before you make a single mark on your support and can be used in conjunction with your viewing frame.

THE RULE OF THIRDS

Artists throughout the ages have devised various formulae that help create good composition, the most famous being the Golden Section, a mathematical formula on which many images and classical buildings have been based. A similar version is the 'rule of thirds'. This uses four lines that divide the picture area into nine areas of equal size and shape. The theory is that placing important elements on or around the lines or at the points where they intersect results in a pleasing composition. While it won't take care of all the aspects of composition, the theory does work and is certainly worth considering when you are planning out your image.

The rule of thirds: Placing objects on the horizontal and vertical lines, especially at their intersections, helps to construct a strong composition. Glueing pieces of string to your viewfinder enables you to see these crucial points when you look through it.

Making a viewfinder: Cutting two L shapes out of card allows you to try looking at your subject through different permutations of size and format.

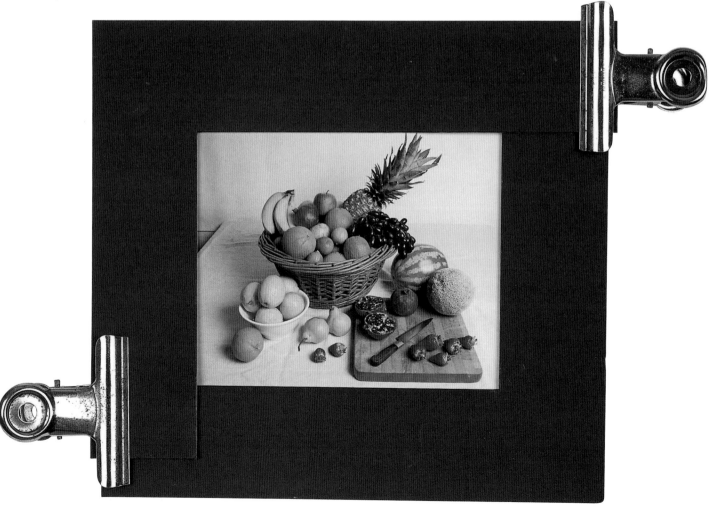

Horizontal format: When the viewer looks at a painting with a horizontal format their eye examines the composition from side to side.

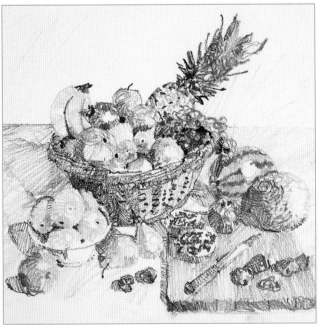

Square format: Here the eye explores the picture in all directions, finally focusing on the centre.

Vertical format: With the same subject given a vertical format, the eye reads up and down.

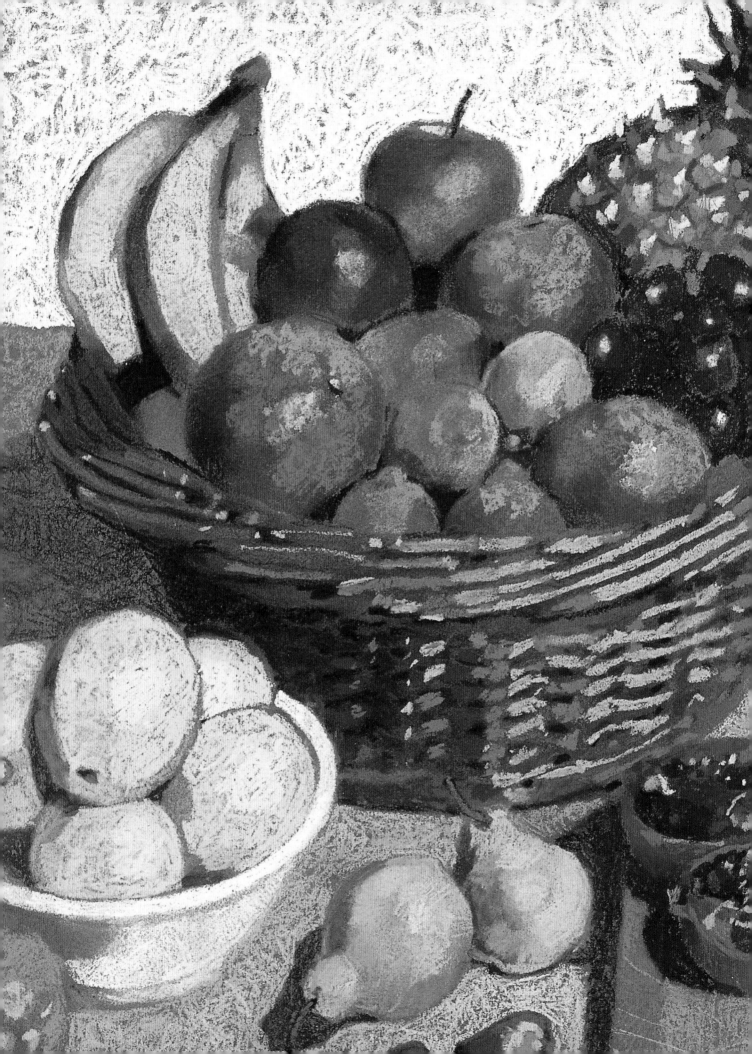

Step 10
bringing it
all together

focus: still life with fruit

Materials

53 x 74 cm (21 x 29 in) light brown pastel paper

Fixative

Brush or rag

Hard and soft pastels:

- *White*
- *Ivory*
- *Light cool grey*
- *Dark cool grey*
- *Dark warm grey*
- *Light warm grey*
- *Warm grey*
- *Payne's grey*
- *Grey green*
- *Oxide of chromium*
- *Light green*
- *Mid green*
- *Dark green*
- *Lime green*
- *Viridian*
- *Yellow ochre*
- *Cadmium yellow*
- *Cadmium yellow deep*
- *Lemon yellow*
- *Cadmium red*

The fruit collected here, with its varied shapes, colours and surface textures, is all readily available from most fruit and vegetable stores. It provides the perfect subject for a pastel still life and in painting it you will employ many of the techniques that have been covered in the previous nine steps. Because this is quite a complex subject, you will need to make a drawing before you start the underpainting.

- *Dark red*
- *Crimson*
- *Burnt umber*
- *Vandyke brown*

- *Raw sienna*
- *Raw umber*
- *Raw umber light*
- *Orange*

- *Deep orange*
- *Violet*
- *Light violet*
- *Cerulean blue*

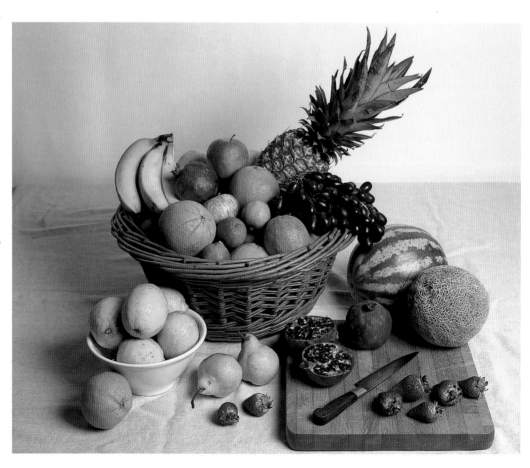

Stage 1: making an initial drawing

1 Begin by loosely mapping out the composition with a hard white pastel. Work lightly, using simple shapes. You can draw and redraw until the composition is correct and, if you wish to, carefully erase any lines you feel are incorrect. However, remember that all of the marks you make at this stage will be covered up with subsequent applications of pastel.

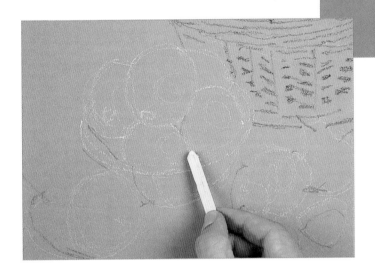

2 Once everything is satisfactorily positioned, redraw the fruit and its containers, using hard pastels in colours that approximately match those of each object being drawn. As before, work lightly so as to avoid a build up of pastel. When you are redrawing, always draw from observation rather than simply following previously applied lines. Use the inital drawing as a guide only.

3 Use a brush or a rag to remove surplus pigment dust. Once you are happy with the shape and position of everything you can apply a coat of fixative in order to prevent the drawing being erased or smudged by the side of your hand as you work.

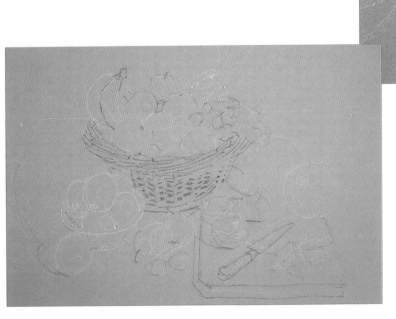

4 All of the elements are now correctly positioned and the drawing will provide a good foundation and guide for the work to come.

Stage 2: underpainting the fruit in the basket

5 Using hard pastels throughout the underpainting, start to block in the image, beginning with the bananas. Use dark warm grey for the stalk end, dark green and yellow ochre for the shaded side and light green for the end of each banana, with cadmium yellow for the main colour. Give a quick blend with your finger to soften the colour slightly.

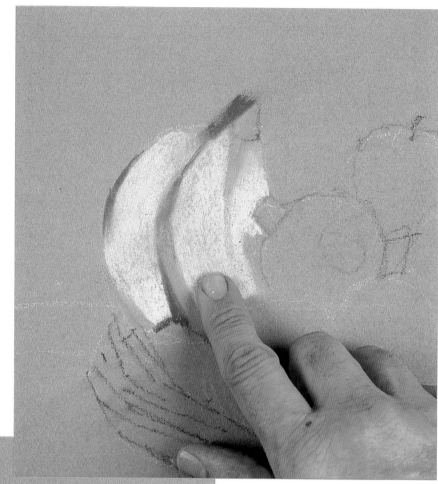

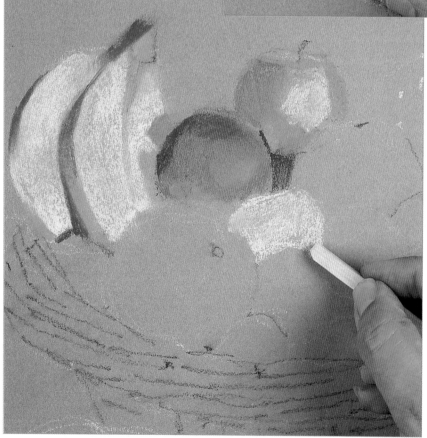

6 Now turn to the adjoining pomegranate, using cadmium red, burnt umber and orange. Block in the red apple with cadmium red, orange and cadmium yellow, then use light green and cadmium yellow for the lower apple. As before, soften the colours with your finger or a torchon.

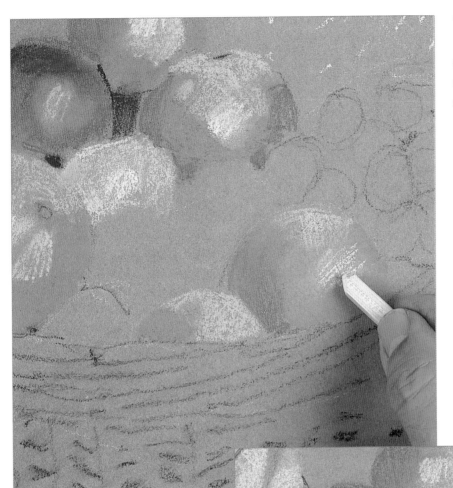

7 Block in the oranges using the same technique and applications of deep orange, orange, cadmium yellow and cadmium red. Add a little ivory to suggest the highlight.

8 For the shadows on the limes, apply light green, dark green and grey green and, as before, add ivory to the highlight. Use the dark green to apply a little of the reflected colour from the limes onto the side of the orange.

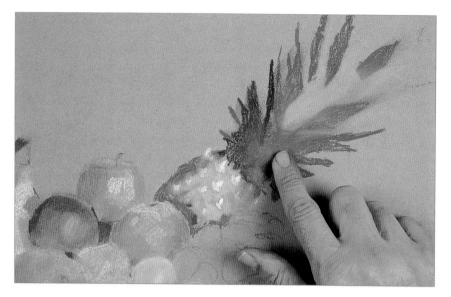

9 You will need several different colour combinations to block in the pineapple: ivory and yellow ochre with a little burnt umber for the segments, with extra details put in with light green and grey green; and dark warm grey, grey green and oxide of chromium for the leaves. Once they are applied, soften the colour with your finger.

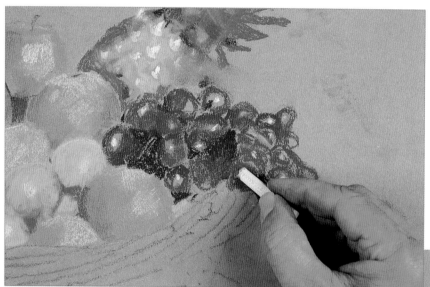

10 Complete the fruit in the basket with the addition of the grapes. Use dark red for the main colour with the addition of a little violet, touches of ivory to create the highlights and light green for the stem.

11 You will have now roughly blocked in all of the fruit in the basket and can, if you wish, give the image a spray with fixative. Notice how already the colour of the support is unifying the pastels and creating a colour harmony.

Stage 3: completing the underpainting

12 Block in the orange on the tablecloth using the same colours as in the oranges in the basket. Establish the shaded side of the lemons with burnt umber, raw sienna and yellow ochre, and use cadmium yellow deep, cadmium yellow and lemon yellow for their lit side. Block in the bowl with white, placing touches of dark warm grey to provide the shadow beneath the lemons and a little orange to suggest the reflected colour from the orange standing in front.

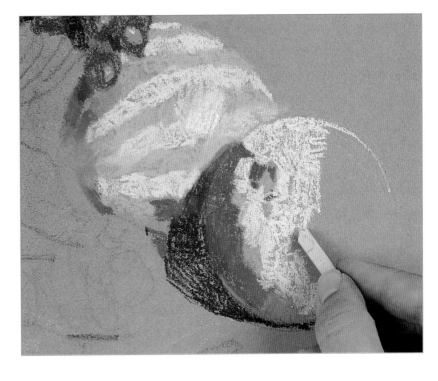

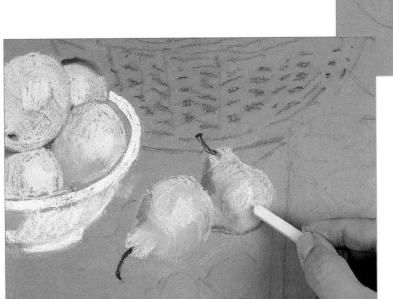

13 Move across to the pears and put in the stalks with burnt umber. Apply a little dark green for the shadows and a combination of light green overworked with cadmium yellow to provide the local colour. Add ivory for the highlights and soften them with your finger.

14 Next, block in the watermelon, using raw sienna at the basket end and dark green and grey green for the shadows. Put in the darker pattern with light green and mid green and the lighter pattern with lime green. Apply a little cerulean blue to represent the highlight and blend it into the surrounding greens with your finger. Use dark cool grey for the shadow of the other melon and dark warm grey, burnt umber and a little raw sienna on the fruit itself. Apply touches of warm grey and yellow ochre to the end of the fruit and then block it in using light warm grey.

15 For the pomegranates, use a combination of cadmium red, crimson and dark red, with burnt umber for the centre and a little light violet and raw sienna for the highlights. Establish the shadows with dark cool grey. Paint the strawberries with light and mid green for the stalks and crimson, cadmium red and burnt umber for the fruits themselves, adding subtle touches of light violet and ivory to provide the highlights.

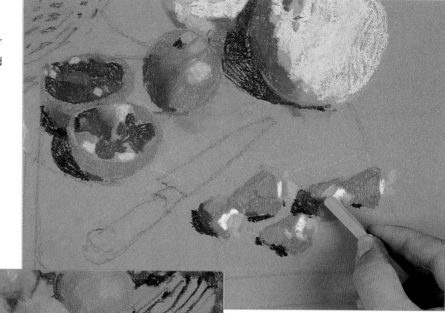

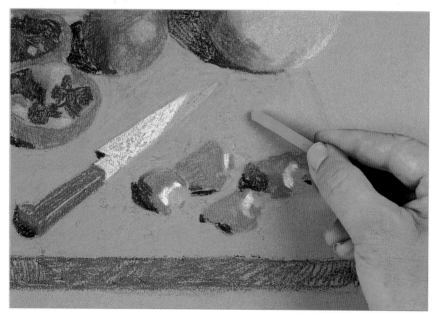

16 Suggest the deep shadows on the basket with Vandyke brown. Use raw sienna on the basket rim and burnt umber for the mid-toned wicker, working carefully to give the sense of the intricate weave.

17 Block in the handle of the knife and the front edge of the cutting board, using the same burnt umber pastel. Apply yellow ochre for the brass centre on the knife and light warm grey and warm grey for the blade. Next, paint the top of the cutting block with raw sienna.

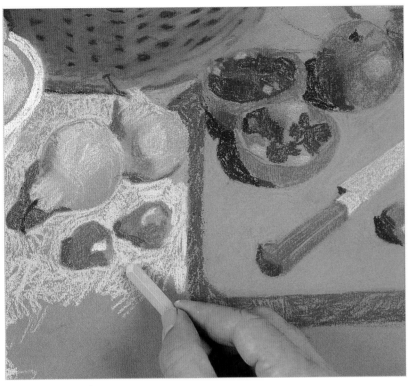

18 Use white for the wall at the back of the still life then block in the tablecloth with the same light warm grey you used on the knife blade. Once these two areas have been established the still life will appear anchored to the tablecloth rather than seeming to float in mid-air.

19 The image and the colours are now firmly established. Fixing the image at this stage will enable you to add further applications of pastel but will also slightly darken the pastel colours already applied. This is no bad thing as it simply serves to widen your palette of colours, with further applications looking especially bright.

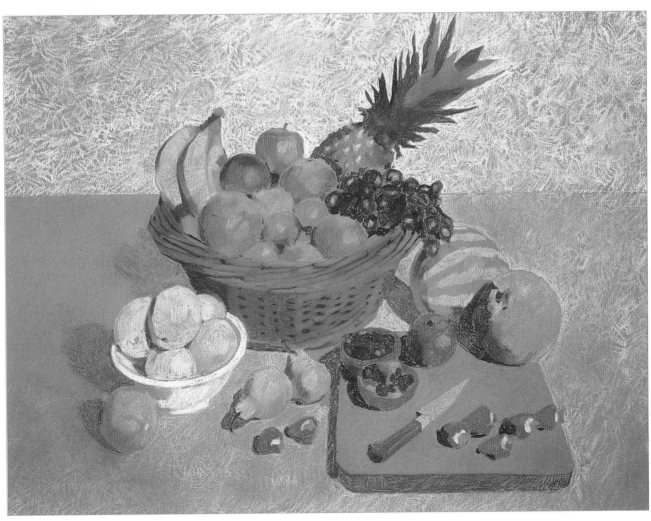

Stage 4: developing the fruit basket

20 Now turn to your soft pastels and repaint the light side of the bananas, using cadmium yellow. Apart from a little added dark grey in the shadows, leave the shaded sides of the bananas alone.

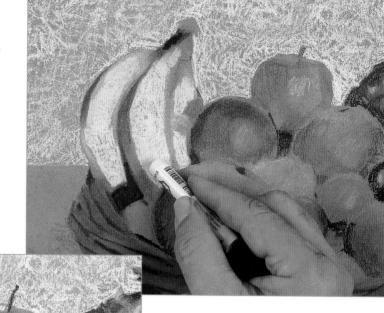

21 Strengthen the colours on the pomegranate, using cadmium red, dark red, deep orange and burnt umber, then touch in the highlight with ivory. Rework the apple with cadmium red and a little lime green blended in with your finger. Strengthen the lower apple with lime green and add an ivory highlight.

22 Repaint the oranges, with cadmium red and deep orange in the shadows and orange for the bulk of the colour. As before, provide the highlights with touches of ivory.

23 Treat the limes similarly, with grey green and viridian in the shadows and mid green and lime green adding form to the fruit. Again, use ivory for the highlights.

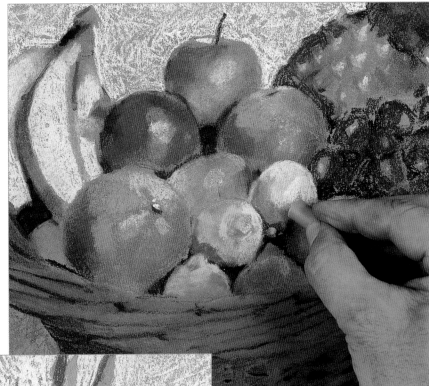

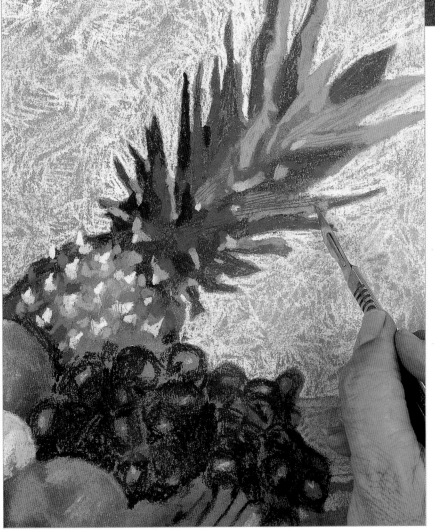

24 Repaint the body of the pineapple with dabs of ivory, yellow ochre, raw sienna, light green, mid green and dark green, describing the sections on its surface. Add further applications of dark green to the foliage and touches of cerulean blue together with oxide of chromium to describe the lighter areas. With a scalpel or sharp-pointed craft knife, add surface texture to both the fruit itself and the pointed foliage by scratching into the pastel.

25 Strengthen the grapes with applications of dark red and Payne's grey added into the shadows between and around each oval fruit. Describe the highlights with dabs of brilliant white.

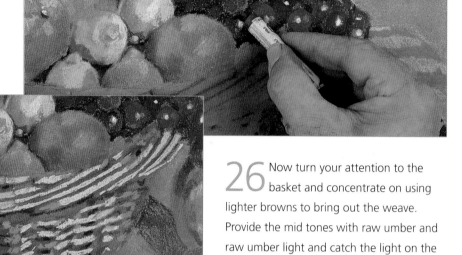

26 Now turn your attention to the basket and concentrate on using lighter browns to bring out the weave. Provide the mid tones with raw umber and raw umber light and catch the light on the cane work with ivory. Put touches of burnt umber into the shadows and dabs of raw sienna to add a little warmth.

27 The newly applied colours sit well over the subdued fixed underpainting and lend a solidity to the objects that would not be quite so apparent if they had been painted in a single layer. In order to maintain this depth and brilliance of colour it is better to leave the work unfixed.

Stage 5: developing the fruit on the table

28 Now rework the rest of the image in the same way, beginning with the lemons. Use the same colours as before, with lemon yellow providing the lighter areas. Accentuate the crispness of the white bowl with a heavy application of pure white on that side of the bowl in full light.

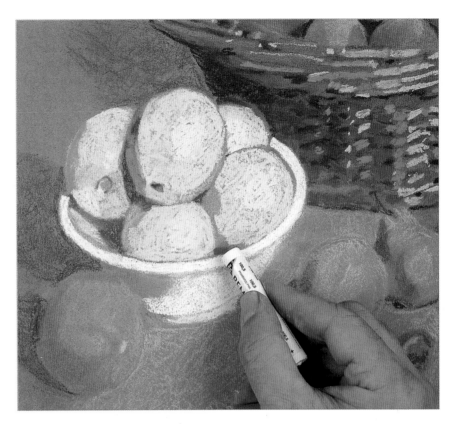

29 Repaint the orange in front of the bowl, using the same range of colours as for the oranges in the basket. Move on to the two pears, repainting them with cadmium yellow, mid green and lime green.

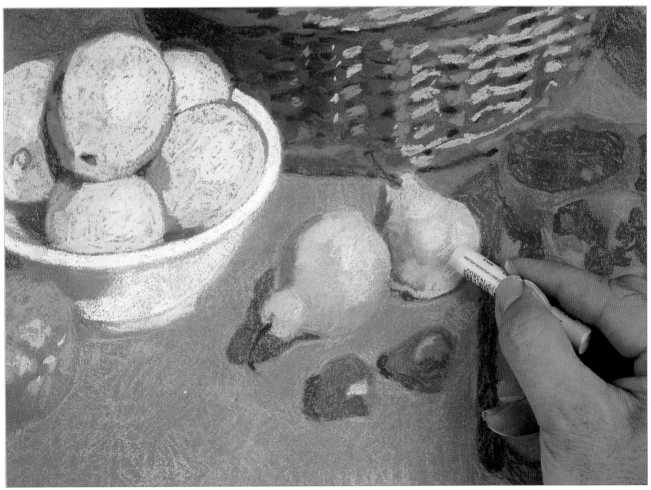

30 Using the same colours as before, repaint the colours on the watermelon but allow the underpainting to show through on the very top of it and in the shadows. The subdued colour helps these two areas to appear to recede. Describe the textured surface of the smaller melon by using an open scumble technique to paint raw sienna and layers of oxide of chromium in the shadows, followed by light warm grey and ivory on the side of the melon catching the light.

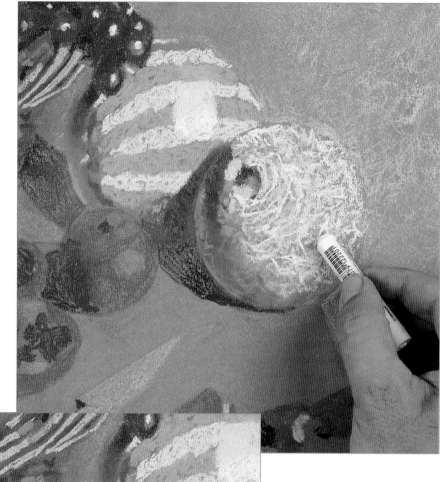

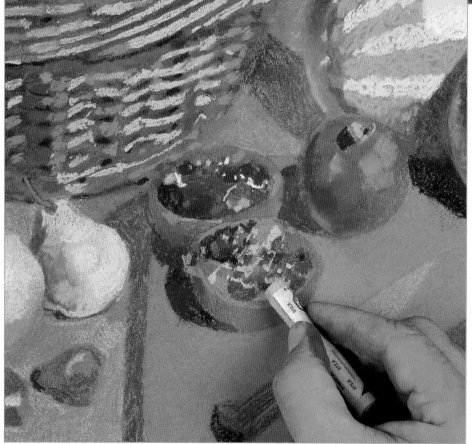

31 Next rework the pomegranates using cadmium red, dark red and deep orange. Bring out the highlights with orange, light violet and ivory.

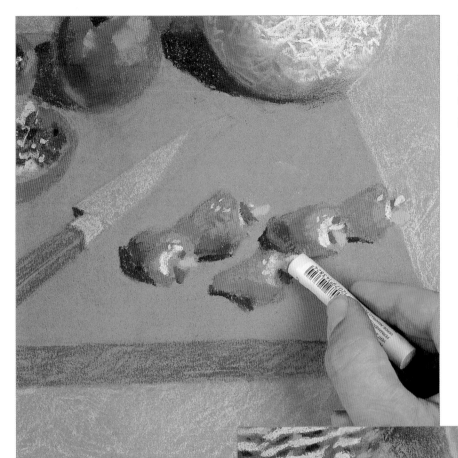

32 Give form to the strawberries with touches of cadmium red, deep orange, light violet and ivory. To bring the small tufts of foliage at the ends to life, paint in light green, grey green and lime green.

33 Next, paint in the strips of wood that make up the wooden block with yellow ochre and raw sienna. Strengthen the darker side using burnt umber. Finally, with ivory and yellow ochre hard pastels, draw fine lines running off at different angles to suggest the cut marks.

34 Add highlights to the knife blade using the light cool grey. Paint the colour of the brass ferrule and pins securing the blade to the handle with yellow ochre and make a few precise marks with white to provide the highlights on both the ferrule and the end of the handle.

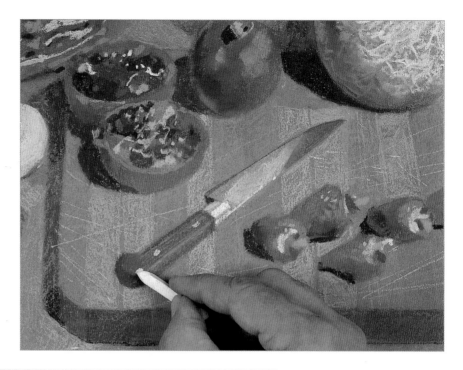

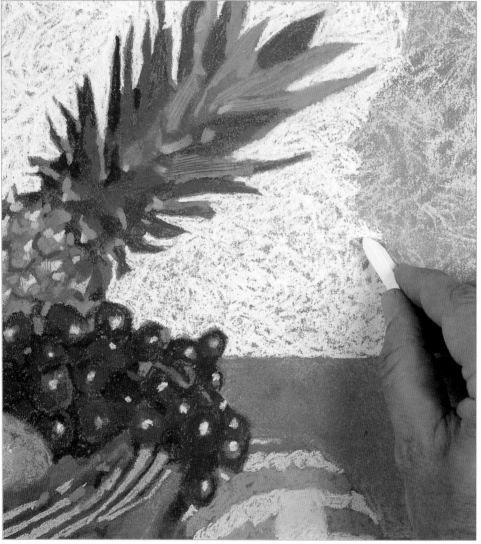

35 Repaint the wall behind the still life, using scribbled heavy applications of white. Cut in carefully around the fruit, especially the pineapple.

36 Give the tablecloth the same treatment. Finally, add dark warm grey into the shadows then paint the whole cloth with a layer of yellow ochre, followed in the lighter areas with ivory.

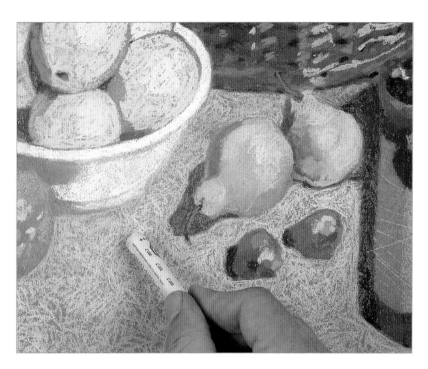

37 Once you have finished the painting you will be tempted to give it a spray of fixative, but this will dull many of the colours, especially the lighter ones. If you do apply fixative, return to and strengthen those colours that need it then leave this final application of colour unfixed.

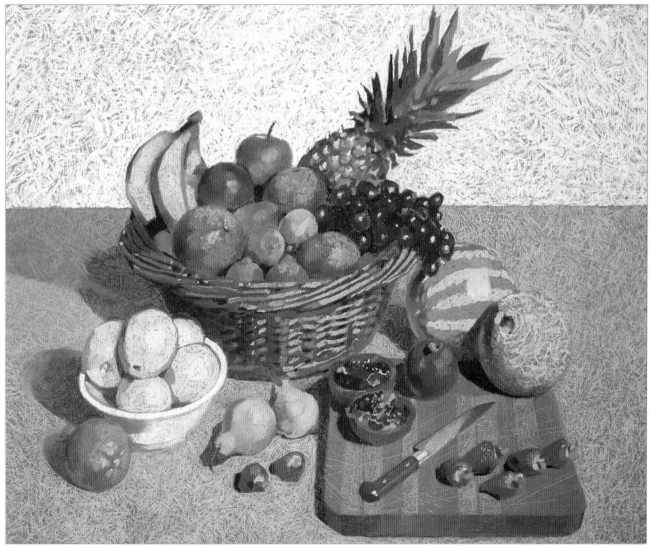

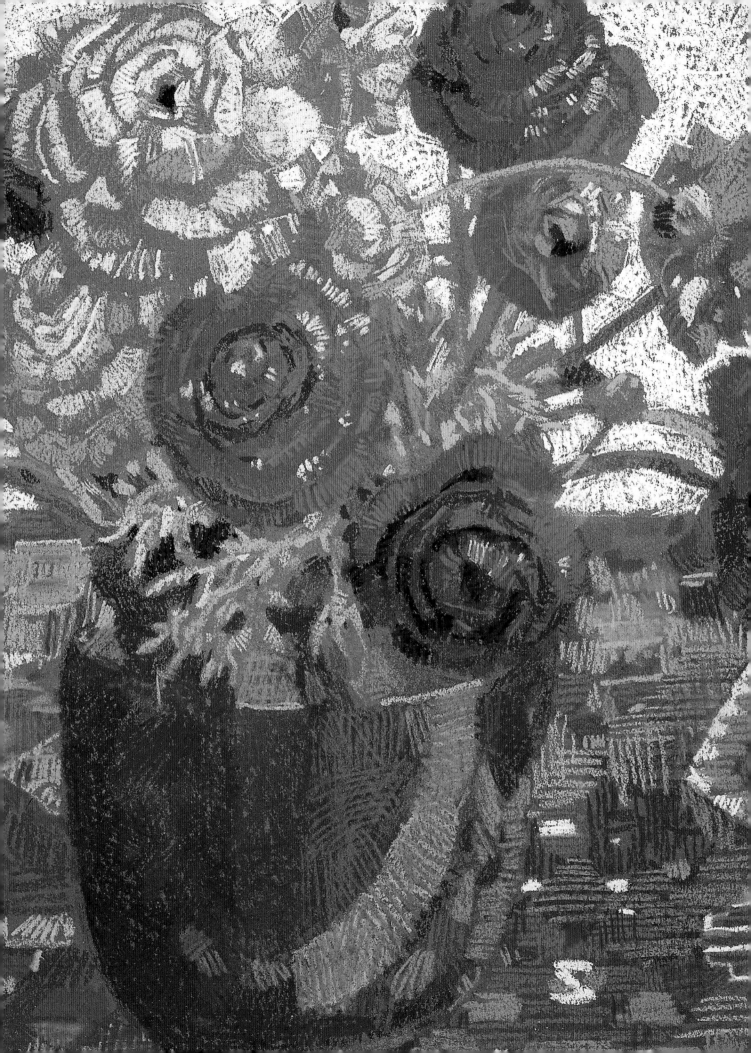

taking it a step further

flowers and landscape

focus: flowers

Materials

53 x 74 cm (21 x 29 in) dark brown
pastel paper

Fixative

Brush or rag

Hard pastels:

- Light cool grey
- Light warm grey
- Cadmium red
- Scarlet
- Crimson
- Pink
- Vandyke brown
- Black
- Deep orange
- Orange
- Cadmium yellow
- Cadmium yellow deep
- Lemon yellow
- Lime green
- Dark green
- Mid green
- Light green
- Grey green
- Dark olive green
- Ultramarine
- Cobalt blue
- Cerulean blue deep

Flowers are always fun to draw and paint, especially when you are using pastels. They lend themselves very well to the subject as you can build up the image using essentially linear techniques which are very controllable. Creating the flowers gradually, using a series of hatched and cross-hatched lines with no use of blending, is ideal for capturing the papery delicacy of their petals.

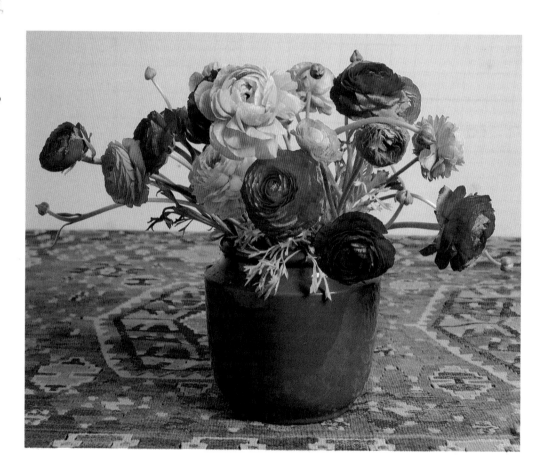

Stage 1: drawing the composition

1 Sharpen a light cool grey pastel to a point and very loosely draft out the position and approximate shape of the elements to be included in the painting. You can adjust this image as much as you wish, as subsequent work will cover all of these lines. Just remember to work lightly and brush off excess pigment once you are happy with the drawing.

2 Next, redraw all of the elements in greater detail, matching the pastel colour to each object and working carefully and lightly.

3 Return to the light grey pastel and draw in the main elements of the pattern on the kilim (oriental rug). This does not need to be exact – it will simply act as an appropriate guide when you apply the colour.

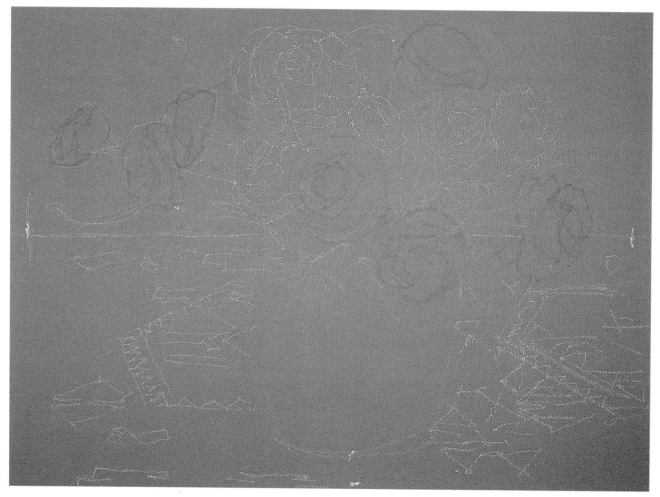

4 You have now established the composition and the drawing will provide a good guide and foundation for the work to come. You can fix this drawing if you wish so that it does not become increasingly indistinct as your hand brushes across it while you work.

Stage 2: establishing shapes and basic colours

5 Starting with the red flower on the extreme left, begin to establish the colour, using cadmium red and scarlet with Vandyke brown added for the darkest shadows. Look carefully at your flowers as you work and try to paint each petal or block of petals separately.

6 Continue the process, working from red flower to red flower. Varying the direction of the strokes to roughly follow the angle of each of the petals helps to make each flower look convincing.

7 Next, draw in the yellow flowers in the centre of the composition by first establishing the darker petals using a deep orange pastel.

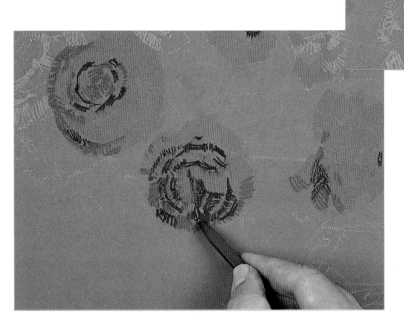

8 Paint the lighter and mid-tone petals on the red flowers on the right-hand side using the cadmium red and the crimson pastels. Draw in the darker petals and the shadows in the petal recesses using Vandyke brown.

9 Return to the central yellow flowers and draw in the mid- and lighter tone petals using cadmium yellow deep. As before, try to vary the direction of the strokes so that they follow the contours of each individual petal.

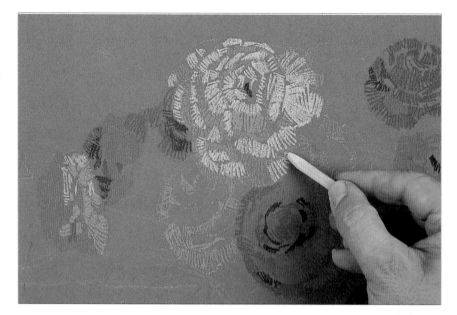

10 Work across to the yellow flowers on the right and establish the lighter tones as before.

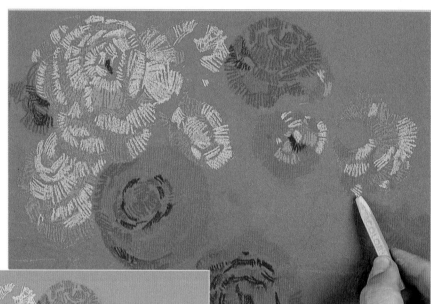

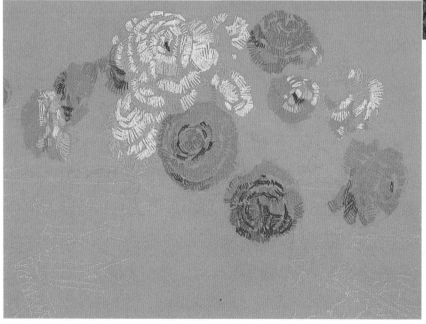

11 You have now established the shape and basic colours of each flower. Although the work is still relatively basic, they already 'read' as complex flowers, thanks to the methodical and thoughtful approach using the initial drawing as a guide.

Stage 3: developing the shapes and background

12 Now turn your attention to the stalks and foliage, using dark green for the areas in deep shadow, mid green for the mid tones and light green for the lighter tones. As before, vary the direction of the strokes, sometimes even working across the width of the stem rather than making marks that only follow its length.

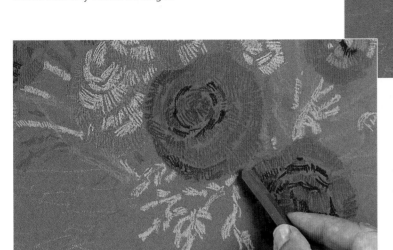

13 Continue to work carefully across the image, carefully searching out the shapes of the stems and foliage using the same three green pastels.

14 Once you have established the flowers and foliage, block in the background. With the light cool grey pastel, carefully work across the white area behind the flowers, using relatively dense cross-hatching. This is an opportunity to carefully reassess the shape of any of the flowers and the foliage. Notice how some of the foliage and darker petal shapes are 'cut out' from the background using the support colour.

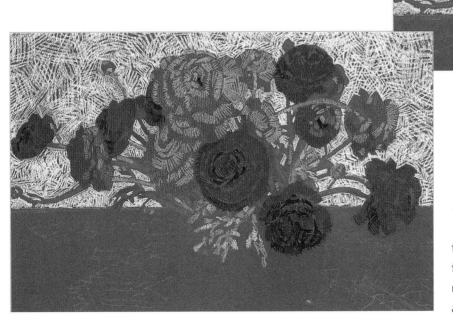

15 Once you have completed the background the true shape of the flowers becomes evident. Those flower shapes that have been represented by the coloured support are now clearly evident.

Stage 4: blocking in the vase and kilim

16 Block in the colours of the vase, using the grey green for the mid tones, dark green for the dark tone and mid green for the lighter tones. Add a small area of dark olive green to the base of the mid-tone area to indicate reflected colour from the kilim.

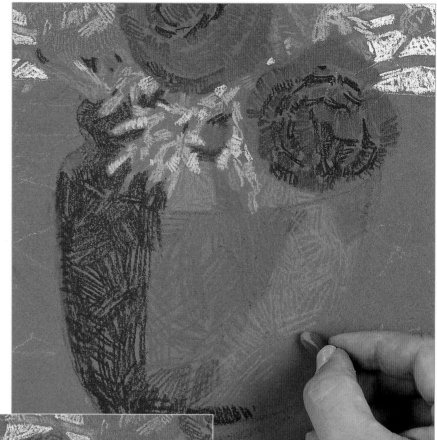

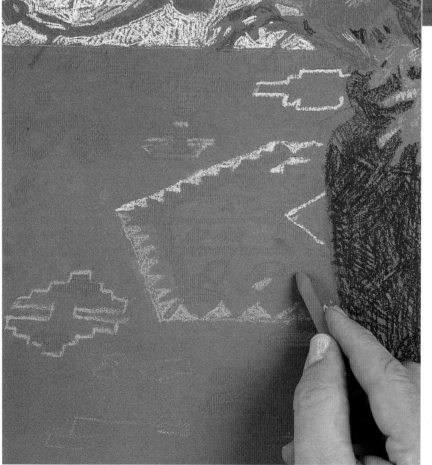

17 Now block in the pattern on the kilim. Begin by drawing in the pattern that is light warm grey in colour followed by the crimson pattern and touches of deep orange. The pattern does not need to be exact, but it does need to be recognizable as a design.

18 Once the red and grey pattern is established, work across the area again using ultramarine and cobalt blue.

19 When you have blocked in the kilim all of the image has been established and it will benefit from an application of fixative to hold the existing colour in place. This will subdue the lighter colours, adding dimension and depth to the colours when you make further applications.

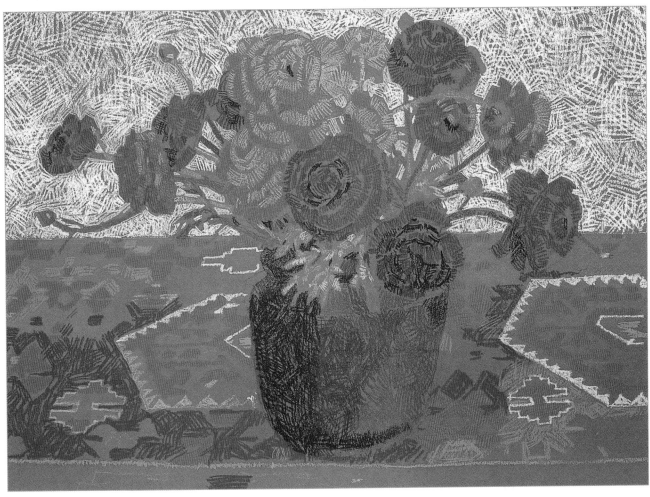

Stage 5: strengthening the colours

20 Now return to the flowers. As before, work across the image, concentrating on the mid and light tones. Use crimson and cadmium red on the red flowers, and cadmium yellow and cadmium yellow deep on the yellow ones. Rework the flowers that are more orange in colour using orange and deep orange.

21 Next, introduce touches of cadmium red and a little crimson into the areas of deep colour on the orange flowers.

22 Reinforce the darkest areas with Vandyke brown. This will have the effect of making the brighter yellow, orange and red hues look even brighter.

23 Rework the background with the light cool grey pastel, using a closer hatching technique to increase the density of the colour. As before, carefully consider the exact shape of each flower as you work.

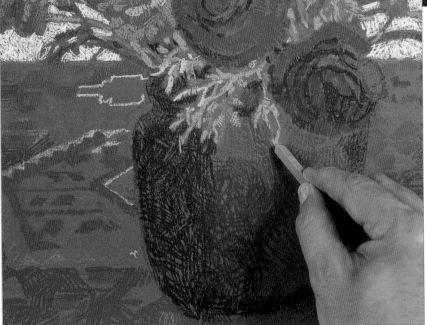

24 Add touches of light, mid and dark green to the stems and foliage. Use lime green for areas that are catching the light.

25 Next, rework the vase. Place touches of cobalt blue on the uppermost left-hand side to hint at reflected light. Use grey green and dark green on those areas where it was previously applied and paint an area of mid green at the top of the vase and in an arc curving down toward the bottom left-hand side. Add touches of crimson to represent the reflected red from the kilim.

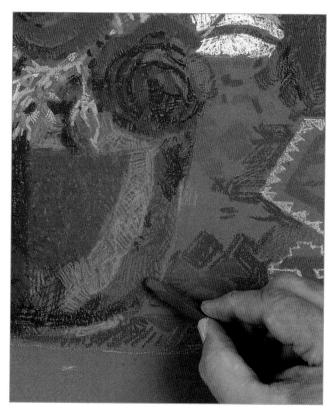

26 After the reworking of the colours the image has much more depth, with the newly applied colours seeming to advance and the visible underpainted colours receding. Notice how the perspective of the pattern on the kilim also helps to suggest depth.

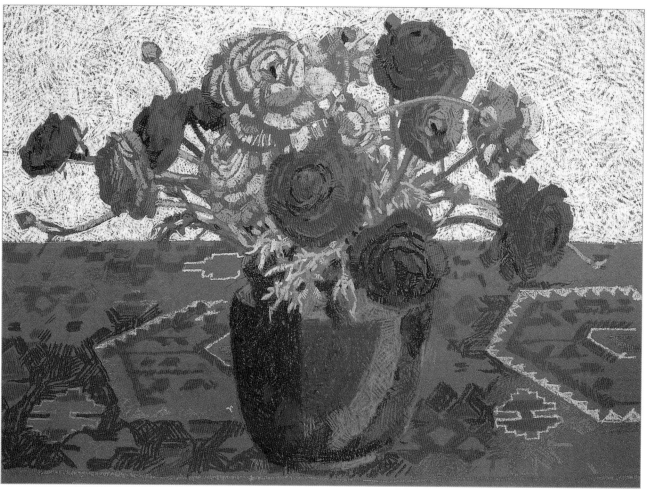

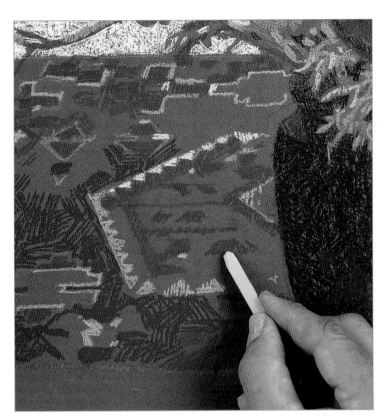

Stage 6: elaborating the final details

27 The kilim now needs extra work in order to bring it up to the same finish as the flowers and jar. Begin by using the light warm grey to elaborate and add to the grey pattern.

28 Build up the pattern, using the mid green and cerulean blue deep. Next, add orange and cadmium red. Notice how the strokes begin to follow the weave of the kilim and how the colours begin to be worked over or across one another.

29 With cerulean blue deep, elaborate the kilim further. Make sure that your strokes are in perspective and follow the orientation of the pattern so that if they were extended they would all run on to meet at approximately the same point in space. This will create a feeling of depth.

30 Strengthen the darkest shadows with black – but be careful, as this can be overpowering. However, you can always subdue the marks by simply pressing the side of your hand onto the mark to remove some of the pigment.

31 Pick out the highlights on the yellow and red flowers, using lemon yellow and pink respectively.

32 Finally, use mid green and cerulean blue deep on the edge of the vase. Moderate the mid tones by cross-hatching over them using the dark green pastel. Notice how the initial layers of dark pastel have become even darker after fixing.

33 The finished image has a brilliance and cleanliness of colour that suits the subject matter. This is due in no small part to the technique used, which keeps any physical mixing of the pastel colours to a bare minimum. In order to keep the colour brilliance, do not fix the image on completion.

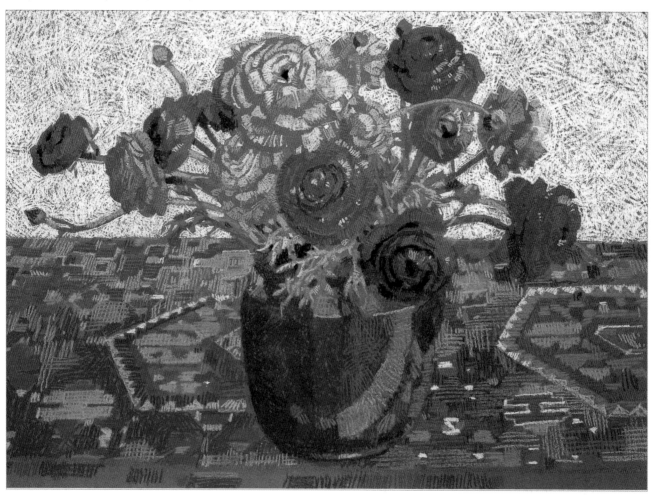

focus: landscape

Materials

53 x 74 cm (21 x 29 in) deep blue
 pastel paper

Fixative

Hard pastels:

- *White*
- *Black*
- *Light warm grey*
- *Dark warm grey*
- *Burnt umber*
- *Raw sienna*
- *Dark raw sienna*
- *Burnt sienna*
- *Yellow ochre*
- *Vandyke brown*
- *Grey green*
- *Dark green*
- *Mid green*
- *Cerulean blue*
- *Cerulean blue deep*
- *Ivory*

Pastels are especially good for rendering atmospheric landscapes, and they are less problematical to take on location than other painting materials as they require no liquid to make them workable. Here, a deep blue support is used which is complementary to the deep oranges used for the dry bracken, giving an image possessed of deep, rich colour that is not immediately apparent in the actual subject.

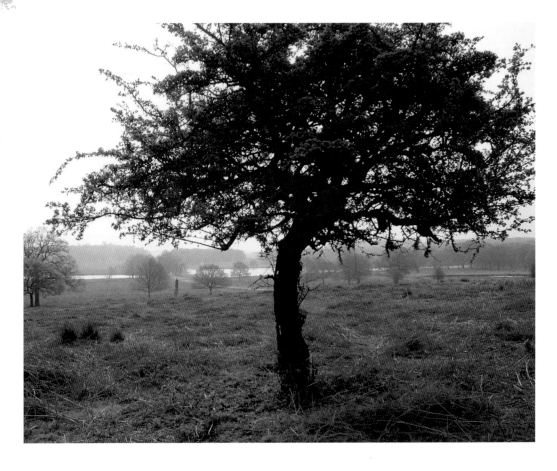

Stage 1: making the underdrawing

1 With the black pastel, loosely draw and plan
out the composition using very simple
shapes and light strokes.

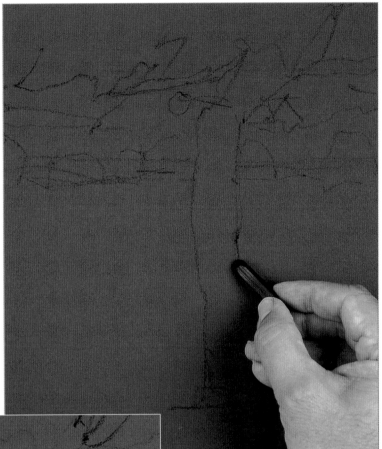

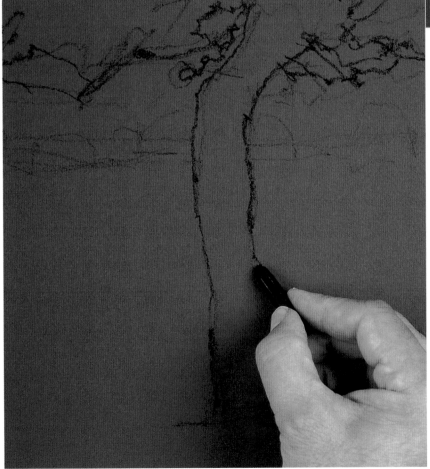

2 Once you are happy with the
composition, rework the tree using
the same black pastel but with stronger,
more precise line work.

3 Redraw the landscape in the distance, using a light warm grey for the distant stands of trees and burnt umber for the individual trees scattered across the middle distance.

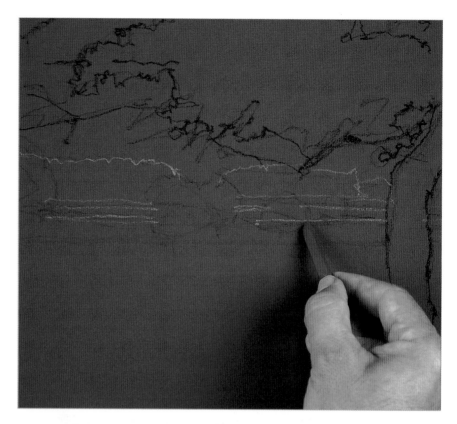

4 The drawing, although very basic, will keep you on track, allowing you to concentrate on the colour combinations that will capture the autumnal atmosphere.

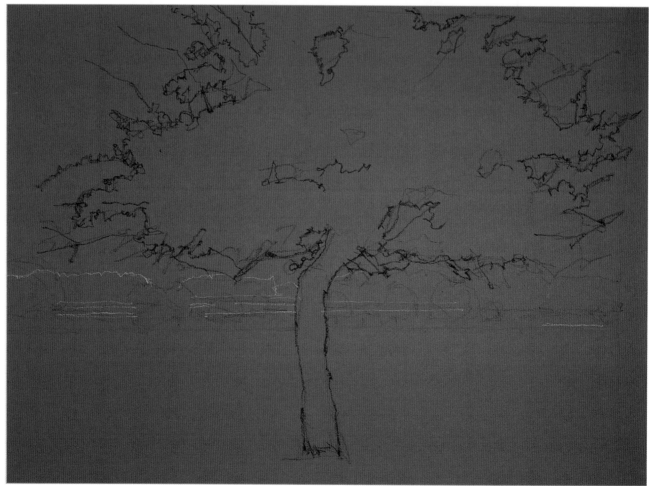

Stage 2: underpainting the composition

5 Begin the underpainting with the large tree that dominates the image, first using dark green and small precise strokes to paint in the foliage.

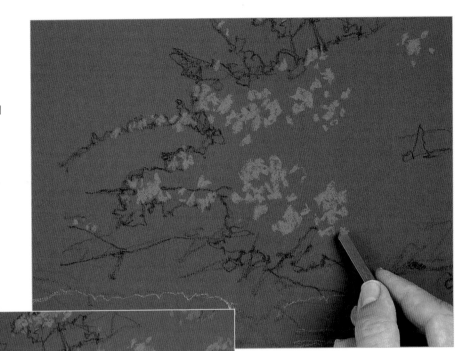

6 Repeat the same small dabs of colour in the tree, this time using dark raw sienna.

7 Strengthen the effect by reworking the area with grey green.

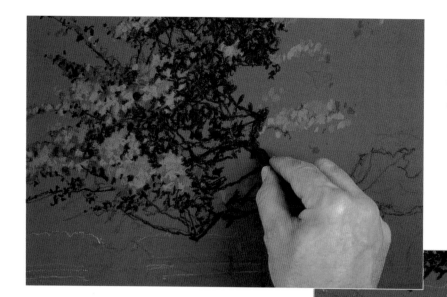

8 Establish the darkest leaves and branches, using the black pastel. Allow plenty of the support colour to show through as the sky colour will need to appear in the gaps all across this area.

9 Paint in the trunk, also with black. Here you can apply the pastel more densely as the trunk of the tree is a dark solid colour.

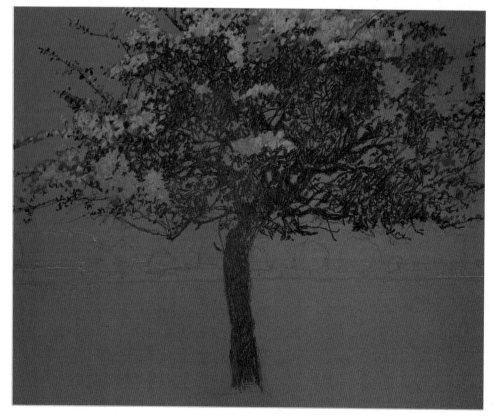

10 The foreground tree has now been blocked in. The open pastel work of the leaves and foliage will allow for more detail around the branches and leaves to be painted in when the sky colour is established in the next step.

Stage 3: blocking in the image

11 Next, paint the sky with cerulean blue. This is an important step as in effect you are painting in the sky as a 'negative shape' which determines the exact positive shape of the tree.

12 Work carefully and allow the blue of the support to also read as leaves and branches rather than simply working around the pastel colours applied in the previous few steps. Use the same colour to suggest the body of water glinting in the distance. If you wish, you can fix the image at this point in order to keep the work you have done so far crisp and in sharp focus.

13 Now establish landscape features in the distance and middle distance. The distance involved and the hazy conditions mean that very little detail is evident and for the most part the work involves simple applications of scribbled colour. Apply burnt umber to the trees along the edge of the water in the middle distance.

14 Next, apply dark green in the same way to the tree on the extreme left and the tops of the stand of trees that runs horizontally to the right-hand side of the image.

15 With the Vandyke brown pastel, put in the darker brown trees and the trunks of the green trees that you painted in the previous step.

16 Use grey green to block in the darker green passages on the stand of green trees.

17 Although the rules of aerial perspective say that colours become cooler in the distance, apply a dark warm grey to the line of trees that can be seen stretching across the horizon. This will be cooled down with subsequent layers of colour.

18 Bring the distant landscape together with the application of dark raw sienna in a band across the distant landmass.

19 Now lay a band of dark green to the area just in front of the body of water on the left. Add raw sienna in front of this and extend it horizontally across the image.

20 Use the mid green pastel on its side to quickly block in the area of grass beneath the tree in the lower left-hand corner of the image.

21 With burnt sienna, use the same technique to block in the rest of the foreground. This will provide a base of slightly uneven colour for the addition of more linear marks that will describe the dried bracken.

22 The image has now been completely blocked in and the overall colour firmly established. You can now begin work developing the colour and improving the impression of aerial perspective. The image can be fixed at this point, a process that will darken the colours already applied and so extend your palette of colours.

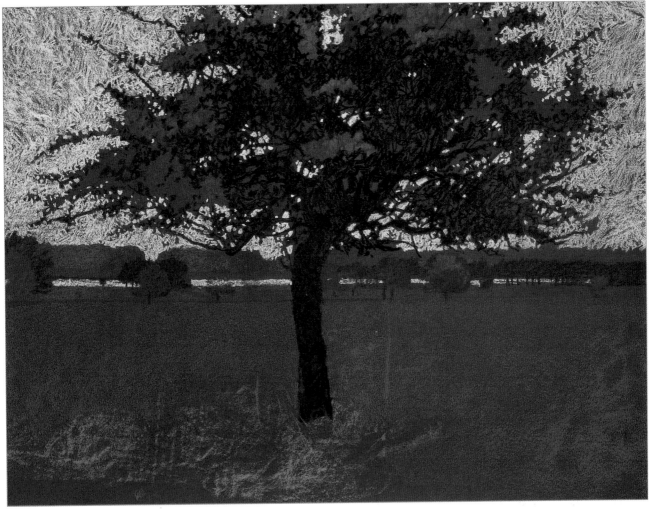

Stage 4: increasing the feeling of recession

23 Begin by reworking and developing the leaves in the tree. Use the dark green, which will appear lighter against the dark green marks that have been fixed.

24 As a counterpoint to the green, rework and strengthen the black. Redefine the branches and add more colour and pigment to the trunk, pulling out and defining a few dried and broken branches near the base of the tree canopy.

25 Repaint the sky with cerulean blue, cutting in carefully around and through the actual tree. Painting in the patches of blue where the sky shows through the leaves and branches will make the tree look convincing.

26 With cerulean blue deep, scumble colour over the stands of trees that run across the horizon. While they were initially painted in warm grey, this cooler colour has the effect of making them appear to be further away.

27 Make the bright band of water sparkle even more by working over the cerulean blue using white. Work over the band of raw sienna that runs horizontally beneath these trees with dark green, then draw in the track with yellow ochre.

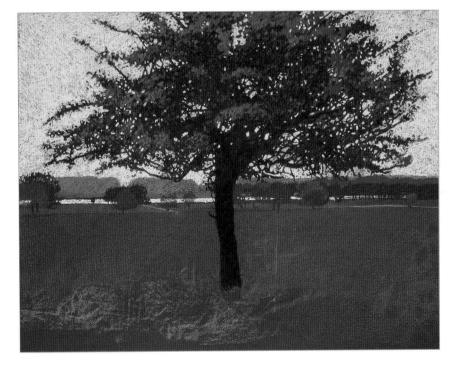

28 Now that the colours in the distance have been modified the feeling of recession is much stronger. The next stage is to develop the foreground to the same degree which will increase the sense of spatial awareness even more.

Stage 5: developing the foreground

29 Reinforce the overall colour of the dried bracken by blocking it in with burnt sienna, using tight linear strokes to create the appearance of the tufts and drifts of bracken. Make the marks larger and more visible as you work towards the foreground.

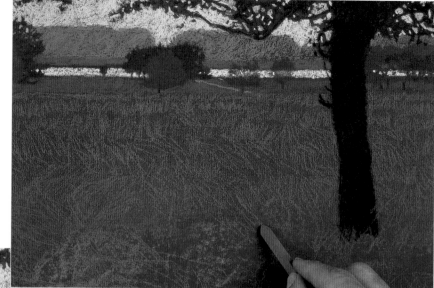

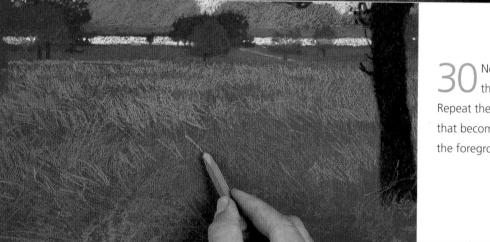

30 Next, work over the area again, this time using yellow ochre. Repeat the process of using strokes that become larger as you approach the foreground.

31 Make an assortment of marks in the foreground with the ivory pastel to suggest the light reflecting off some of the grasses and bracken.

32 Finally, make linear marks to the immediate foreground over the green area, using the mid green. Vary the direction of these strokes to suggest the haphazard tumble of grasses.

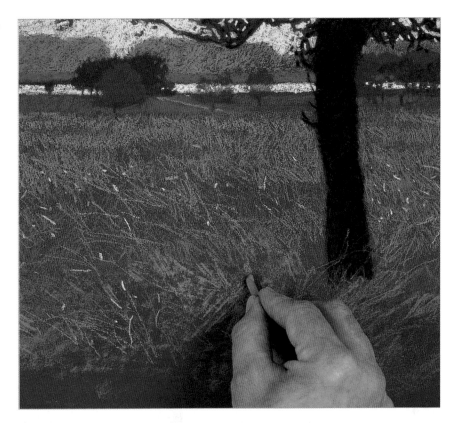

33 The finished image possesses convincing autumnal colour and atmosphere. The classic techniques of using warm colours in the foreground and cooler colours in the background helps the feeling of depth. The deep blue support creates an underlying harmony and is the perfect partner for the warm complementary colours across the foreground.

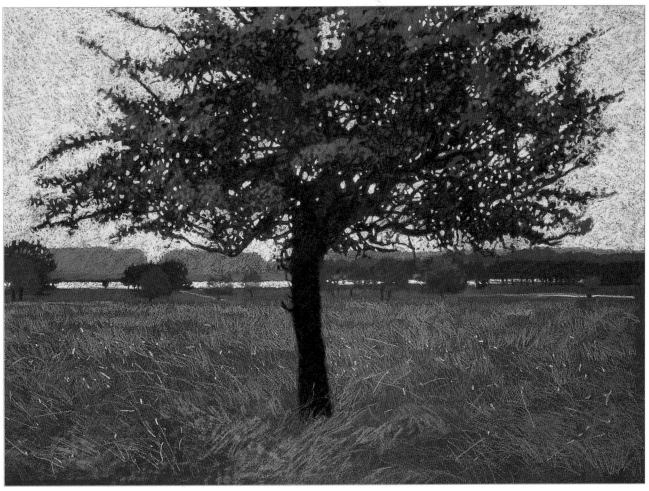

index

a

additive colour mixing 55
aerial perspective and recession 135, 137, 138–9, 141
aerosols 14
analogous harmony 31
apples, in projects
 orange, pear and apple 38–43
 still life with fruit 98, 104
atomizers 14

b

background walls, in projects 85, 87, 103, 110
bananas, in projects
 grapes and bananas 22–7
 still life with fruit 98, 104
basket, in still life with fruit project 97, 102, 106
binders 11
blending 16, 47, 54–5
 pears (on paper bag) project 56–61
 still life with fruit project 98, 100, 101
boards
 chopping boards, in projects 67–71, 102, 109
 drawing boards 17
bowls, in projects 84–7, 101, 107
broken colour 66
brown paper bag, in pears project 56–61
brushes 16, 55, 58, 74

c

ceramic bowls, in projects 84–7, 101, 107
chalks *see hard pastels*
charcoal 23
chopping boards, in projects 67–71, 102, 109
cleaning
 pastels 13
 torchons 16
clips 17
colour mixing 30, 39, 55
 lemon and strawberries project 84–7
 orange, pear and apple project 40–3
colour ranges, pastels 10, 11, 12, 18–19
colour theory 30–1
 aerial perspective 135, 137, 138–9, 141
 orange, lime and lemon project 32–5
colour wheel 30, 31
coloured supports 15, 47, 82–3
 landscape project 128–41
 lemon and strawberries project 84–7

complementary colours 31, 128
complementary harmony 31
composition 90–3
containers, in projects
 baskets 97, 102, 106
 ceramic bowls 84–7, 101, 107
 vases 120, 121, 124, 127
cool colours 31, 135, 139, 141
craft knives and scalpels 17, 38, 47, 75
cross-hatching *see hatching and cross hatching*

d

density, linear techniques 38–9
detailing 23
drawing boards 17
dust removal 23, 74–5

e

easels 17
equipment 10–19
 see also specific equipment (eg supports)
erasing and erasers 16, 74, 75

f

fillers 11
finger-blending 16, 54, 55
fixatives and fixing 14
 impasto 47
 reworking 74–5
 underdrawings and underpaintings 23, 97, 103
flowers (on kilim) project 114–27
formats 90, 93
frames, viewing 90–1, 92
frottage 65, 66
fruit
 still life with fruit 90–111
 see also specific fruit (eg oranges)

g

glazing 65
Golden Section 92
grapes, in projects
 grapes and bananas 22–7
 still life with fruit 100, 106
graphite pencils 23

h

hard pastels
 care 13
 colour range 10, 11, 12, 18–19

construction 11
 linear techniques 38
 manipulation tools 16
 sharpening 17, 38
 textural techniques 64–6
 underpainting 23
harmony, colour 31, 82
hatching and cross-hatching 38–9
 flowers (on kilim) project 114–27
 orange, lemon and lime project 32, 33, 34, 35
 orange, pear and apple project 40–3
horizontal format 90, 93
hue 31

i

impasto 46–7
 melon and pomegranate project 48–51
intensity, colour 31

k

kilim 116, 120–1, 125–6
knives
 craft knives and scalpels 17, 38, 47, 75
 kitchen knives, in projects 67–71, 102, 110
knocking back 25

l

landscape format 90, 93
landscape project 128–41
layering 23, 54–5
 pears (on paper bag) project 56–61
 sgraffito 75
lead-ins 91
lemons, in projects
 lemons and strawberries 82–7
 orange, lime and lemon 30–5
 still life with fruit 101, 107
limes, in projects
 orange, lime and lemon 30–5
 still life with fruit 99, 105
linear techniques 38–9
 erasing and sgraffito 74–5
 flowers (on kilim) project 114–27
 landscape project 137, 140–1
 orange, pear and apple project 40–3
liquid grounds 15

m

mahlsticks 17
mark-making *see linear techniques; textural techniques*

masking 66, 68
masking tape 74
materials 10–19
 see also specific materials (eg supports)
 melons, in projects
 melon and pomegranate 46–51
 still life with fruit 101, 108
monochromatic harmony 31

n
negative shapes 133
neutrals 31, 83

o
optical colour mixing 39
 lemon and strawberries project 84–7
 orange, pear and apple project 40–3
oranges, in projects
 orange, lime and lemon 30–5
 orange, pear and apple 38–43
 still life with fruit 99, 101, 104, 107

p
paper bag, in pears project 56–61
paper stumps (torchons) 16, 55
papers 14–15, 22–3, 46, 82–3
pastel pencils 11, 38
pears, in projects
 orange, pear and apple 38–43
 pears (on paper bag) 54–61
 still life with fruit 101, 107
pencils
 graphite 23
 pastel 11, 38
pigments 11
pineapples, in projects
 pineapple (on tablecloth) 74–9
 still life with fruit 100, 105, 110
point and counterpoint 91
pomegranates, in projects
 melon and pomegranate 46–51
 pomegranates (board and knife)
 64–71
 still life with fruit 98, 102, 104, 108
portrait format 90, 93
preparation and foundation 22–7
pressure 39
primary colours 30
pump-action sprays 14

r
recession and aerial perspective 135, 137,
 138–9, 141
reflected colour 32, 68, 70, 86, 99, 101
reworking 47, 74–5, 97
rule of thirds 92

s
saturation, colour 31
scalpels and craft knives 17, 38, 47, 75
scribbling 68, 87, 110, 133
scumbling 65, 66, 70, 87, 108, 139
secondary colours 31
sgraffito 47, 75
 pineapple (on tablecloth) project 76–9
 still life with fruit project 105
sharpening pastels 17, 38
sketches, thumbnail 91
soft pastels
 care 13
 colour range 10, 11, 12, 18–19
 construction 11
 linear techniques 38
 manipulation tools 16
 sharpening 17, 38
 textural techniques 64–6
 wrappers 11, 13
sprays, fixative 14
square format 90, 93
still life with fruit 90–111
storage boxes 13
strawberries, in projects
 lemons and strawberries 82–7
 still life with fruit 102, 109
stumps, paper (torchons) 16, 55
subtractive colour mixing 55
supports
 colours and tones 15, 47, 82–3, 128
 surfaces and textures 14–15, 22–3, 46, 64

t
tablecloths, in projects
 lemons and strawberries 85, 87
 melon and pomegranate 49, 50, 51
 orange, lime and lemon 34, 35
 orange, pear and apple 42–3
 pears (on paper bag) 58, 61
 pineapple (on tablecloth) 78, 79
 pomegranates (board and knife) 69, 70

still life with fruit 103, 111
temperature, colours 31
tertiary colours 31
textural techniques 64–6
 erasing and sgraffito 74–5
 pomegranates (board and knife) project
 67–71
textures, support surfaces 14–15, 22–3, 46,
 64
thirds, rule of 92
thumbnail sketches 91
tinting papers 15, 83
tonal values 15, 31, 83
torchons (tortillions) 16, 55
trees in landscape project 128–41

u
underdrawing and underpainting 23
 flowers (on kilim) project 115–18
 grapes and bananas project 24–7
 impasto 46–7
 landscape project 129–37
 lemons and strawberries project 84–7
 melon and pomegranate project 48–9
 still life with fruit project 97–103

v
values, tonal 15, 31, 83
vases 120, 121, 124, 127
vertical format 90, 93
viewfinders 90–1, 92
visual balance 91

w
walls, in background in projects 85, 87, 103,
 110
warm colours 31, 141
watermelons, in projects
 melon and pomegranate 46, 51
 still life with fruit 101, 108
wooden boards *see boards*
wrappers 11, 13

acknowledgements

Executive Editor Katy Denny
Editor Kerenza Swift
Executive Art Editor Darren Southern
Designer Miranda Harvey
Production Manager Manjit Sihra
Artist Ian Sidaway
Photography Ian Sidaway and Colin Bowling © Octopus Publishing Group Limited

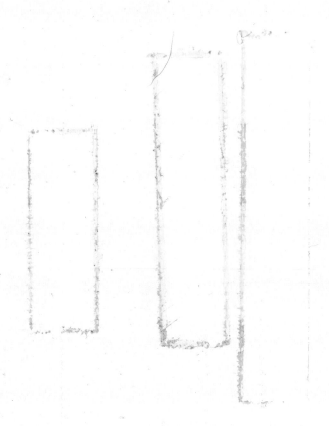